International Standard Book Number: 978-0-86719-852-2
All rights ignored, all lefts reversed...
Copywrong 2016 @ (Chicken John isn't a registered trademark)
This book is printed in Canada by Friesens Corporation
Any copying of this book is encouraged. Duh.

www.chickenjohn.com

Edited by Benjamin Wachs
Cover illustration by Nicolas Weidinger and Dustin Selman using free
and open Force Directed Graph that was built on D3.js
Back cover photo by Julian Cash www.supersnail.com
Layout, design, graphs and craft bitters: RICK! Abruzzo

Additional editing, proofreading and idea extraction:
Brian Doherty
Deanna Fleysher
Miriam Fathalla
Anne-Marie Litak
Anita Marie Tsaasan
Orange Box Man
Sondra Carr
Tycho Gallinaccio
Seana Miracle
Paradox Pollack
Charley Hasenbeck

Additional inspiration:
Lee van Laer
Birgitta Jónsdóttir
Madia Alva Roff

And of course: Hieronymus Bosch

Enless gratitude and adoration for my wife Eileen and our Alicemonster.

San Francisco Institute of Possibility
3359 Cesar Chavez Street
San Francisco Ca 94110

www.sfiop.org

The Book of the Un

Friends of Smiley

Dissertations from Dystopia

by Chicken John Rinaldi

edited by Benjamin Wachs

This book is dedicated to Darryl Van Rhey, whoever he is.

"The universe is made of stories not atoms." —*Muriel Rukeyser*

*Every story is a story about a person with power
who underestimated their enemy.*

Sorcery

I've been waiting around for years for somebody else to write this book. You know, an "expert." A guy with a fancy degree who can't take your call because he's on the other line with Malcolm Gladwell writing a TED talk on how to get the rednecks to return to a "dignity culture" and stop with the "honor culture" bullshit already.

Anyway, I figured one of those guys was going to write this book, and then I could spend my time telling everybody "YES! This is the book and THAT'S the guy and let's all go park our trailers next to his house!"

But that guy didn't write the book. Neither did Malcolm Gladwell. So even though I'm not the guy, I should write it. Because I think the world needs this book. Because I'm pretty sure, when I look around, that there's a whole bunch of other people hoping that somebody writes this book. And maybe one of them is The Guy. Or can be The Guy. I bet one of them can be The Guy.

Actually, I bet most of them can be The Guy. That's kind of the point. If you take one thing away from this sentence, it's that you and all your friends can be The Guy.

The only problem with being The Guy is that you can make the same mistakes the last guys did. If there is one problem that people who are ready and willing to change the world make, it's that they invariably try the same things that didn't work

before but they do it the exact same way, and—*TA* DA!—nothing good happens. It's like the world's worst magic trick. A magician who keeps pulling a dead rabbit out of his hat. (No actual rabbits were harmed in the making of this metaphor.) I mean, it's a good trick, pulling a dead rabbit out of a hat. But if it didn't wow the crowd the first time, it's not going to do it the 2nd. Or 22nd.

Trust me, I have done that show.

And if there *is* one thing I know, it's wowing crowds. And really disappointing them. I've done both, a lot. I don't know anything about honor culture or dignity culture, or quantitative easing (which somebody told me is a real thing, I swear), but I know how to work a crowd. And I know how to get them to do impossible things.

Because I create magic moments.

Well, that's a pompous statement, but I liked the way it just hangs there, all full of itself. I should really say something like: "I create magic moments when everything works perfectly." Or maybe: "I create magic moments. A little." I mean, it does happen. If you would like to know how, and what is involved in living your life like a comedy act/disaster movie, then you should read my other book *The Book of the Is.* That's a different book. That's not this book. That's a book about *individuals* creating magic moments, it's about living your life as if there were no consequences and it's about embracing failure—true, utter failure as a welcome destination. This is a book about how arts *organizations* create magic moments—and the systems that create them and why they fail so often, and how they can not fail so much. And how, once more organizations are not failing (or when they start failing in the right ways), they become movements. And how it is inevitable that these movements will create a global understanding. This book will deconstruct the systems that foster the Chaos that creates the ecology that makes the art that changes the world with pure magic.

I know, I know…'change the world.' I kinda can't believe I'm saying it either. But ya know—magic moments. Do you get it? *MAGIC* moments. Where impossible things happen. Affirming things. Beautiful things. Which is what we need right now, right? In this world? Fuck yea we need more magic moments.

But let's talk about those impossible things, very quickly, for just a moment, in case you haven't actually read *The Book of the IS* and you're not going to. Or maybe you meant to, but then you got distracted by the 247 pictures of me and my dog, which is what happened to a lot of people. They didn't read that first book so much as stare at it a long time. That's why there are no pretty pictures in this book. Just charts and graphs. I think that's gonna go better, because this time people will pretend to read the charts and graphs instead of pretending to read the words.

It actually makes me wonder if the guys who did the cave paintings had this prob-

lem. "Hey Thog! Did you look at my cave painting? Did you? You didn't, did you. You just stared at the fire that whole time…" That happened. You can't tell me that didn't happen.

There are probably other templates to explain this work. They're probably not as funny. For me, everything is skewed to shows. You should know this simple fact. And you should know these two concepts from *The Book of the Is* that you have to understand when we talk about magic moments in show:

- Severe Comedy™

- Engineered Disperfection™

Severe Comedy: Living/life as art in all your moments

Severe Comedy is what I end up with when I describe a show without actors. Comedy is truth. It always has to be. That's the severity of it. No stage, no fake props. Just life lived in show. Salvador Dali did not take hallucinogens: "I am hallucinogenic" he said.[1] I didn't do a show about running for mayor, I ran for mayor and turned it into a show. Edward Snowden didn't write a spy novel, he became a spy.

That kind of thing. Violating your contract with 'belief.' And when things are real and not acted, sometimes you can see God through a performance/performer. When something is so amazing and beautiful/hysterical/somber/confounding you are presented with the opportunity for transcendence. It works in strange, mysterious ways. If you are knitting your brow over this complex topic, that's because you're not used to seeing real life as a prop. Once you start, believe me, it's everywhere. You will see going to the dentist as a one-act play. You will see a couple arguing on the street as the beginning of a music video. You will see global politics as a problem you can solve with puppets. You will see our national apathy and the obscene void of corporate work culture as problems to be solved with magic moments in show.

Engineered Disperfection: Distressed engineering that incorporates non-fulfillment

It's a situation that is perfectly set up for assumptions about the world to be broken. It's kryptonite for expectations. Really, actually being OK with totally not winning. All the stupid shit I do is defined by this idea. The idea that success is something that happens *before* you give 100%. And who wants to not have the experience of going 'all the way'? And yes, you fail but you gotta be able to fail confidently. Not calibrating to success is a kind of freedom from the machine that is forever pushing

1 "Take me, I am the drug; take me, I am *hallucinogenic*." —*Salvador Dali* [†]

us to mediocrity. Success is usually some metric that other people hold anyway. When you engineer disperfection, you see hope as a kind of fear. When we embrace failure, architect it even, we can manufacture culture that changes the world.

When you get right down to it, all our convictions, our history, our treasures and our monuments will all be so much stardust someday. Our true destination is cosmic dandruff. All life is an engineered disperfection. This is an idea that may be useful practice for us someday, no?

> "HE SAW THAT ALL THE STRUGGLES OF LIFE WERE INCESSANT, LABORIOUS, PAINFUL, THAT NOTHING WAS DONE QUICKLY, WITHOUT LABOR, THAT IT HAD TO UNDERGO A THOUSAND FONDLINGS, REVISINGS, MOLDINGS, ADDINGS, REMOVINGS, GRAFTINGS, TEARINGS, CORRECTINGS, SMOOTHINGS, REBUILDINGS, RECONSIDERINGS, NAILINGS, TACKINGS, CHIPPINGS, HAMMERINGS, HOISTINGS, CONNECTINGS—ALL THE POOR FUMBLING UNCERTAIN INCOMPLETIONS OF HUMAN ENDEAVOR. THEY WENT ON FOREVER AND WERE FOREVER INCOMPLETE, FAR FROM PERFECT, REFINED, OR SMOOTH, FULL OF TERRIBLE MEMORIES OF FAILURE AND FEARS OF FAILURE, YET, IN THE WAY OF THINGS, SOMEHOW NOBLE, COMPLETE, AND SHINING IN THE END."
>
> —*JACK KEROUAC*[†]

Pain, poverty and ridicule

But there's no sure thing in magic. These moments don't have a formula I can just give you here with words. It's not something that can be described in passing, it will take this whole book to do that. But even without understanding the magic that happens through a show, you already know that people give their lives to that magic. I totally have. Especially the magic that comes through collaborative artworks. They endure pain and hardship. Poverty and ridicule. They are attracted to that magic, that 'anything can happen' feeling. They find tremendous value in it and chase it forever. The first book in this series details with painstaking accuracy the toil and hardship that I made everyone around me suffer through for my affiliation to this idea. But surely you see that *everybody* gives their life to something. Sometimes it's noble: "he gave his life for his country" or it's "she gave her life to her kids." Sometimes people give their lives to their tv's or their fucking jobs. Their addictions. Their obsessions. Their fears. Your life is totally going to elapse. It's going to get used up. You can do a lot worse than trying to touch the ineffable in clownface.

Some of the things I'm going to suggest in this book are going to sound delusional. Outrageous. At first they may seem like giant leaps over boiling hot lava-logic. This is my dissertation, from the dystopian present presenting the inevitable utopian

future. It's possible that at the end of this book I will have changed your mind about what possibility is. It's all from my lens, a guy who lives in show. And you do kinda have to live it. It's not a theory, it's practice. There's no such thing with magic moments as "it worked on paper." There's no "the simulation predicts." Everything with magic moments that matters is happening on the ground, in real life, in real time, in person. Blink and it changes.

Which means it's not predictable, and that's actually a pretty big deal. Let's talk about 'predictability,' and what that means.

It's a trap!

Science requires replication. Repeatability. If you can't do the experiment over and over again, and get the same results, then science isn't interested. You have to be able to put the same inputs in, and do the same thing, and get the same output, over and over. This is how it works.

You know what else requires repeatability? Marketing. People who spend tons of money on marketing want a system, a machine, where they can be sure that if they spend X money on ad buys across channel Y, it's going to lead to a Z% increase in sales. They're looking for certainty. Sure, marketing may be 'creative,' but they don't really want 'creativity,' they want a button they can push over and over to get the same result. If they can hire an intern to push the button, they will. If they can hire a monkey to do it, they will. Ideally, though, they just want a machine that pushes its own button. Saves money on bananas.

Once you start looking for this, you see it everywhere. We design so many things in our culture to be machines, whose only virtue is that they're repeatable, which means they're predictable. Look at education.

What? Education? Am I crazy? Sure. Everybody knows that. But look at it anyway: how do we know that somebody gets to graduate? In most places, and more every year, you take a test. And what kind of test? In most places, and more every year, it's a multiple choice test. So the system isn't on the lookout for new and creative thinking, it doesn't respond well to novel approaches. It's a machine. And the ideal result, the system we're trying desperately to create, is one where we have to spend the least amount of money and do the least amount of work to get every student to fill out the bubbles on the sheet the same way. And if a monkey could do it we'd give him a diploma. We want the same inputs to yield the same output every time. Repeatability.

So we've got science, marketing, education...we've got factories, we've got computers, we've got pharmaceuticals. We've got agriculture, we've got I.T., we've got retail. And all of them work—or are supposed to work, we're trying to get them to

work—like machines. You know that if you just press the button, this is what's going to happen. Take the pill, this is how you feel. Go through the lecture, this is what you'll think. I'm bored already. Are you?

Magic moments don't work like that. You cannot control them. They're not predictable. They're not repeatable. They're not produced by machines, because they don't come out of mechanistic systems.

You can *cultivate* a magic moment. You can create the conditions under which magic moments are more likely to appear. But it's a completely different set of conditions, and a completely different kind of system. You're not looking for repeatability, you're looking for inspiration. The environments that cultivate magic moments aren't machines, they're organisms, like Djinn or sprites. Or angels.

What matters isn't so much what they are made of, but how they act. The same materials can be used for different purposes. Take education. In a mechanistic system, designed for repeatability, you give the kid a lecture and insist that he use it to come up with the same answers as everybody else. In an organismic system, you give the kid a lecture and encourage him to respond in a way nobody else ever has before.

That's a tall order. Most of the time he'll end up repeating somebody else, whether he knows it or not. But the experience, for him, of trying to be original will be completely different from the experience of trying to be indistinguishable from everybody else. He'll learn different things. And if he does make it? If he comes up with something truly original?

Magic.

This means that the same systems created to be part of a giant machine can also be used as parts of a giant organism. Every ad, every car, every thing that man makes or manipulates is setting a scene for an interaction that can be magical if we do it right. Our entire civilization is a set, a collaborative artwork for interaction.

This is what we are talking about when we say <living your life as art.> It's not a broad, general term. It's committing to the art, in your moments: leaving room for inspiration where you'd otherwise only have repetition. And if you do that, if you exercise that muscle, you find yourself experiencing the magic moments more frequently and more deeply. The definition of sadness changes when you find there can be magic moments in your darkest hours. Amazing, transcendent moments of connection, awe and grace are common among grieving people when all the pretense is stripped away. It is known. It's all some heavy shit when you start writing it down. But no matter how good at it you get, moments that offer a conduit to the

divine are never just going to be repeatable the way science wants it to be, or pharmaceutical companies want it to be, or marketing wants it to be. Machines would love to do the same thing every time—*if* they were capable of love.

Organisms hate that. When you try to force them to repeat the same tasks the exact same way over and over again? They feel enslaved. Their health suffers. They get angry. They get apathetic. Or they kick your ass.

If you want to work with an organism, you have to inspire it. If you want a magic moment, you create the ecology for one to exist, then you summon it. And if you're lucky, one comes. This I have proven in show. Over and over again, a thousand different ways. You know it when you see it and if you ride in my truck with me long enough you will see it and you will know. What I'm telling you in this book is that it scales to everything else. All other aspects of life including, but not limited to: everything.

The more you commit to your world being like a machine, the more mechanistic it acts and the more repeatability you get. The more you commit to your world being like an organism, the more it acts like one, and the more magic moments you get. In all facets.

Which is on the one hand their biggest weakness: they're not predictable, they're magic. But this is also their strength: because they happen on the ground, in real life in real time, they can have an effect that other things can't. Because they break systems and shatter assumptions, they can do what models and theories based in systems and assumptions can't. People are drawn to them, they crave them, they live for that space where "anything can happen." They get the experience once and then are forever looking for it again. They just don't know how to get to it. There are A LOT of these people. They are figuring it out. They are divesting in the mediocrity of the machine culture. They are investing in the movements that get them back there. If they can see how these ideas scale, and if enough people are hooked on creating enough magic moments, I bet we can solve truly massive problems. I think that there actually is no other way to solve some of the giant problems we are having now. Because the world has gone about as far as it can go treating its systems like machines. Don't get me wrong—that accomplished a lot. A huge amount. Do you want to see how much it's accomplished? I can show you. Global problems are absolutely shrinking. You shouldn't believe that just because I said it. I mean, what do I know about the shrinkening of global problems? A little. Enough. I mean, you aren't reading this book because of my knack for collating statistics. You are reading my book because I'm good at violating your expectations. Many other people have written books about shrinkening global problems, I'll cite them in my:

HARPERS INDEX OF WORLD PROBLEM SHRINKENING[†]

Percentage of people self-employed in the US 1948: 18.5%

Percentage of people self-employed in the US 1990: 8.7

Percentage of people self-employed in the US 2014: 30%

City that has highest number of people filing taxes as artists: Oakland, CA

Current number of artists in the US: 2,438,948

Number of people in the USA who work: 125,520,000

Predicted number of artists when the US has 50% unemployment: 50,982,287

Year that it is predicted that the US will have at least 50% unemployment: 2036

Number of people who possess as much wealth as 50% of the worlds population: 82

Number of people worldwide who have attended a Maker Faire: 5,000,000

Year in which President Martin van Buren issued the order for ten-hour work day: 1840

Year in which Sweden adopted the six hour workday: 2016

Global infant mortality rate 1900: 10.2%

Global infant mortality rate 1975: 8.8%

Global infant mortality rate 2015: 3.2%

Amount of non-profit giving in 1974: $125,000,000,000 (adjusted for inflation)

Amount given in 2015: $400,000,000,000

Number of non-profits in 1975: 220,000

Number of non-profits in 2015: 1,500,000

Average salary of a farmer in rural Europe in 1510 (adjusted for inflation): $15,000

Average salary of same farmer in 1840 (adjusted for inflation): $15,000

Average salary of same farmer today: $75,000

Number of people globally that have access to a working toilet in 2014: 66%

Percentage of people globally that have a cell phone in 2013: 86%

Number of buildings over 1,000 years old covered by cell phone ads in Venice, Italy: 92

Percentage that tourism has dropped in Venice because of ads: 36%

Percentage that female circumcision is down since 1970: 60%

Percentage of male-to-female trans operations are up from 1975: 19,540%

Year when 'extreme starvation' worldwide fell below 10%: 2014

Years in which the % of people experiencing obesity/starvation flip-flopped: 1970/2012

Number of calories in a Subway Italian Classic: 479

Number of counts of child pornography Jared Fogle the Subway guy was charged with: 343

Number of bombers the USA manufactured for WWII from 1941 to 1947: 350,000

Number of wind turbines needed to supply 100% of the world's power needs: 7 million

Do you see? Things have been getting better. Way better. And they can get better still. But not if we keep trying to build a better machine. We don't want to give up on repeatability, but we've gone as far as it can take us. We need inspiration. We need to start cultivating inspiration and magic, which means treating our systems like organisms. And the way to do this is:

- elevating the status of art/show in our cultures to create magic/impossible times

- experimenting with constitution writing in our festivals and other spaces

- connecting with each other through movements and using play as activism

- doing as much of this as we can outside of commerce.

If we embrace these systems on *these* levels, then eventually they will be implemented on *all* levels. I've literally watched it happen my whole life. Collaborative artworks can make huge impacts, affect culture and drive national conversation. It all scales. What we do matters.

This is our shot, our time to take all the investment and all the tools and make that magic and do something big with it. Outside of commerce, outside of lines on maps. I know, it's a lot to swallow here only on page 9. But this is a thesis of how we, as a people, get to the good stuff: Peace, prosperity, ecology and balance.

Seriously. It's going to be artists, making magic moments, that get us there.

We know it won't be the unions, it won't be the politicians, it won't be the religions, the military or the media. It won't be corporations or banksters or the materialists. It won't be the new agers or the historians or the lobbyists or the tech-sector billionaires. They've all had their chances. They've had chances after chances. They're like the broke guy at the casino trying to get more chips with an IOU because he's finally got a system he knows will work this time.

The worst thing that can happen is that the guy gets more chips. It doesn't matter what his system is: It's. Never. Going. To. Work.

IF the world can be ushered into a time of compassion and reason, it'll be us who do it: the artists with the magic of collaboration, communication and play. By not making the mistakes of the past, we can make magic that is more important than money and create micro-systems of wonder and transcendence that can and will scale. I'll show you what that inevitability can look like. And how I recommend that

we, somehow, create an open-source global thesis for artists, for our festival culture and for any movement that happens outside of commerce and national borders. I have no idea how to do this...but I know that if it *could* be done, humankind would experience a gracious revolution unlike anything we have ever seen before. We are all owned by the banksters, the war machine and the power brokers. Everyone is working on managing scarcity to their advantage, when we could be working on how to manage abundance to everyone's advantage. There has got to be a way to win, and it lies in our creative work making the world smaller. I'm talking about the combination of art and innovation, direct voting in a post-capitalist resource-based system, open borders, Universal Basic Income etc...pushing towards utopia is noble work. Or in this case noble play. But there are better avenues for chasing the blueprints to this utopia than with me. Still, I saw a bunch of weird, fantastic patterns that I wanted to share with you. Because they made me look at the world differently. Not hopeful, more like... trustful. I'm going to try to show you these systems: from the show magic, to the collaborative art groups to the constitutions that bind those groups to the micro-movements that those groups make to the movement of movements that is sweeping the globe now.

It's a lot, sure. Let's see if I can do it.

Fictional Elven lands...

Let's have a dream sequence, shall we?

Well, it works in movies. They make it look easy.

Imagine please, for a moment, what utopia actually looks like. No no no...not the Big Rock Candy Mountain. A utopia within the confines of our current physics and physical limitations. No D&D magic. No fireballs, no wish spells. Nothing special happens if you roll a natural 20.

What would utopia look like? Would we have electric cars that drove themselves? Would you only work if you really wanted to? Would we live to be 150 or more years? Would systemic racism, income disparity and cancer be gone? Drugs be legal? Religion diminished? Would sex be better, food be easier to grow and politicians held to their promises? Shows be given as gifts? Would every song ever recorded be on your phone? And would that phone be the size of a stamp? Maybe utopia for you is no war. Or a place where people who are trans or LGBT or fantastically abled are equal without question. Would there be Basic Income for anyone who made less than (today's) $15,000, thereby eliminating poverty and the humiliation of the welfare state? Would there be no dumb jobs like toll collectors? Would the arts proliferate in this place?

Where is this place? It's here. In the U.S. and everywhere else. The real question is: when is it? It's sooner than you could ever possibly imagine.

The utopia I described above is, I believe, an inevitability. Sure, it won't *actually* be a utopia. There will be people in it. It'll have problems. Reality TV will still suck. Your grandmother will still not understand your hobbies. The 'check engine' light on your hovercar will keep turning on for no apparent reason. But the trend of shrinkening problems will continue. And you, and a bunch of artists, are going to do it.

Let's get to it.

Fail Graph

I've given you five years to think about the Fail Graph. Lets look at it again, and see if it rings any truer than it did all those years ago, shall we?

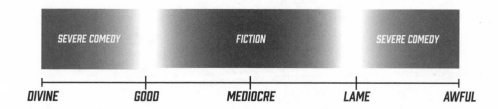

Now, let's make sure you are using the Fail Graph correctly. You see where it says Fiction there, and the other thing that says Severe Comedy? You pick one. Either something is one *or* the other. That's how it's helping you.

Let's pick something to make a good example of, shall we? How about a ventriloquist named Nina Conti. Check her out, she's amazing. She puts masks on volunteers from the audience then manipulates the masks' mouths to make the people seem like they are talking and it's pretty brilliant. She uses audience members as her dummies.[2] Now, go watch a 5 minute video of Nina. I'll wait. Done? Good. Where is Nina on the Fail Graph?

2 they are all shills, have I taught you anything?

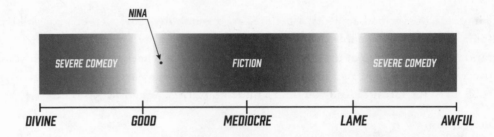

The difference between something that can only ever be mediocre (lame to good) and something that *can* touch the divine is that there is a risk that it could suck because it's not fiction. Nina kills EVERY NIGHT. She destroys the audience over and over again, leaving murdered dead bodies in all the seats. It's never terrible. Which means it's either only ever *good* on the Fiction Graph or it's always *divine* on the Severe Comedy Graph.

I'm sorry. Truly sorry. It's *good* on the Fiction Graph. And I mean it when I say I'm sorry. Because there is no risk and because there is no rarity and it's totally fiction, that is the way it is. It's entertainment. Great, amazing entertainment. Which we need. We should have great entertainment. But that's not what I'm talking about when I'm describing the fragile, delicate electric moment of summoning possibility. Nina is not going to topple governments and bring about a new age of understanding. The new renaissance of art can be entertaining, but it's not *just* entertainment. The reason I'm so sorry is because once you start looking at things like this, you kinda can't go back. So I'm sorry.

But I'm not sorry that you can see the magic ever brighter now. 'You know it when you see it' has become a blinding, brilliant conduit to an endless well of authenticity. Where am I trying to go here? I'm trying to get you to see the places it *can* be, and a little nudge to help make it happen. There are thousands of examples, the idea is that you have to strip away restrictions and consequences and all the bullshit to get something that is real. To get to something that is magical. That's what's important. And you also have to see the system in how you do things so you don't fall into the trap of reading the script the machine of convention is telling you to. And *that* is really hard.

One more time!

We have to make sure you understand how to use the Fail Graph. It's crucial. I don't want to hit you over the head with it, I just want you to know it. To love it. I want you to rub the Fail Graph all over your naked body. I want you to invest. I implore you to find a situation you were in and put it on the Fail Graph and see how you did. I'm going to return to the Fail Graph often so you have to really understand how it works. My own lovely wife Eileen didn't 'get it'. She was struggling with this book, in a conversation over a fancy dinner, it hit her like a ton of bricks. She's been using the Fail Graph all this time, she just didn't know it.

Eileen is in the café business. She's a smart, effective, hard-nosed entrepreneur with a degree from Brown, and she's a really good kisser. She is forever speaking at the women entrepreneur conference or going to the merchants' association meeting and has even been invited to Washington to meet with Obama's cabinet members as a representative of woman-owned manufacturing companies. She has hundreds of wholesale clients and she is constantly mentoring people (mostly women) who are just getting in the game. What does she tell them? How does she advise someone who is opening their first café?

This well-educated, successful lady tells her clients to open a café and exclusively play Van Halen really loud and only serve cold brew coffee.

This is the exact example she gives. She explained it to me, in between bites of pork tenderloin she was eating, and then she got it, that's she's been using the Fail Graph all along and didn't know it. She looked at me in a certain way that I've seen many, many times before. *The look.* It's the (*Oh, I just thought you were out of your fucking mind and was just going it along with it but now I see that your position is actually complex and just needed to be explained better or I needed to actually listen to you*) look. It happens all the time.

Now wait a minute. I know what you're thinking: you are trying to wrap your head around why she is recommending people blast Van Halen and serve cold brew coffee as a business model that will be successful. What possible sense does that make? Well, if you look at the alternative, it's your only choice. Let's call the alternative: Turkey Sandwich. So on one hand you have Van Halen and cold brew. On the other hand, you have a café that has muffins, coffee, tea, kombucha, juices, bagels, sandwich meats, soda, granola, brownies and so on. Which café is going to work? Let's use the Fail Graph!!!

Here's how it works: Turkey Sandwich invests a ton of money in her café to cook food. It takes more capital, more space, more permits and the day she opens she's in $100K more debt than the Van Halen café. It takes more money to operate her café.

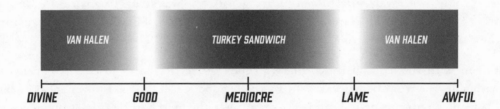

| DIVINE | GOOD | MEDIOCRE | LAME | AWFUL |

She needs more employees, she has more stock, perishable foods, plus the profit margin on a bagel isn't very much...To keep up with the hemorrhaging of money, she switches from Ritual Coffee as her wholesale account to Mr. Espresso. Saves her a little money. Uses the cheaper meat place to get her cold cuts. Saves her another little bit. Pays her employees as little as she can. Cuts hours the café is open. Fires the cleaning company, makes her barista clean the bathroom. The list goes on, you see what is happening...the bathroom is disgusting, the coffee sucks, the turkey sandwiches are made by miserable, low-paid wage slaves that could give a shit and the sandwich isn't even that good. Turkey Sandwich is a forgettable place on par with every airport café you've ever visited.

But none of that is even the real point. The fact is that Van Halen is a *story*. Turkey Sandwich isn't a story. Turkey Sandwich is a mediocre lunch spot you go to if you're in a hurry. You get a coffee there because you live down the block and it's the closest place. Your customers have zero loyalty. You put the place up for sale in the first 6 months because it's just not working. Meanwhile, Van Halen café business is booming. Maybe. Maybe it's a dismal catastrophe and not a single customer ever walks through the door. There is risk in opening a business. But Turkey Sandwich was guaranteed to fail, while Van Halen could have a line down the block or just that one guy with the Van Halen t-shirt that goes there every day and is ALWAYS there. (Don't be that guy.)

This is my wife talking, up there. These are the words coming out of her mouth. I say to her, "That's the Fail Graph." She cocks her head a little. "Really?" Then I get *the look*. "Oooohhh. That's very good, honey. You should explain it better. I totally didn't get it." ...ai yi yi...

I can give you example after example, but this is all you need: you can't really love a turkey sandwich. You can't be passionate about it. But there are a billion people who love Van Halen (including this author!) and you can totally evangelize for the new 4th wave movement of coffee: cold brew! You can show with charts and graphs the science of why cold brew is better and how VH makes coffee taste better or whatever. It's a story. The place becomes a destination. It's fun. And since it's all you do, you make the best cold brew on Earth. You start selling it in bottles. Then, in six-packs. You get a contract for Whole Foods. Your place becomes a magical experience. Eddie Van Halen stops by one day, because he read about it in the NY Times. He gives you his red/white stripey guitar to display on the wall. Tourists come from all over to see it. You open another location in Tokyo. But only play Rush. This would be divine on the Fail Chart. Awful would be if no one came, and you didn't have anyone to tell the story to. But the VH café could never be mediocre. Impossible.

Eileen tells people "You have to crush it. Or walk away." That's great life advice.

There are a thousand other examples, the idea is that you have to strip away restrictions and consequences and all the bullshit to get something that is real. To get to something that is magical. That's what's important. And you also have to see the system in how you do things so you don't fall into the trap of reading the directions that the mechanistic world wrote for you. If all the café people and the store people and the movie theatre people and the car people and so on all did this, if they all did their version of the Van Halen café? That's the world I wanna live in.

EVERY COLLEGE GRADUATION SPEAKER SPEAKS OF REACHING FOR THE STARS, THEN THEY DON'T GIVE YOU ANY TOOLS TO DO ANY OF IT. AGAIN: THEY TELL THE KIDS TO REACH FOR THE STARS AND THEN JUST STAND THERE WHILE THEY FLAIL AROUND WASTING THEIR TIME OR GET BURNED OUT. THE BEST IDEAS, INNOVATIONS AND ART IS COMING OUT OF PEOPLE THAT ARE UNDER 25. IT SEEMS LIKE WHEN SOMEONE THAT YOUNG IS DOING SOMETHING GREAT, IT'S AN ANOMALY. BUT THE *REAL* ANOMALY IS THAT THE FUCKING MACHINE LET THAT KID BREAK THROUGH AND GET THE OPPORTUNITY. IF WE LET MORE KIDS BREAK OUT OF THE CONTROL OF THE MACHINE THE WORLD WOULD BE BETTER FOR IT. INVESTING IN YOUNGER PEOPLE IS HOW YOU PAY RENT FOR THE BODY YOU'RE LEASING. AND YOU WON'T BE SORRY. ALL THEY WANNA DO IS CREATE A WORLD FULL OF CURIOSITY AND WONDER.

Show me the money!

I discovered flamenco too late. I'm simply too old to ever be able to play my guitar in anything more than a pedestrian way in regards to Spanish music. There just aren't enough years left in my body to develop the techniques. I ran out of road. Maybe next time. Have you ever experienced flamenco? It's a stunning, powerful

thing. The music has a sadness to it absent from our pop music candy-coated crap, but also a sureness. A dignity. A resolve. The dancers embody striking poise and yet somehow easy comfort. The hand gestures look like flowers and the poly-rhythms they clap transfix you and you get lost in the beauty. The fire roars. The wine flows. The guitars thrum in perfect syncopation to percussive stomping and the throaty singing of songs about young love lost, an amplitude of stars litters the night sky as this show is presented to anyone within earshot as a gift. Imagine, if you would for a moment, that this show is a place a magical creature would like to visit. A Djinn or a Fey creature, like a fairy, an imp or maybe just a spirit.

The Spanish call this: *the duende.*

> "*THE DUENDE* IS A MOMENTARY BURST OF INSPIRATION, THE BLUSH OF ALL THAT IS TRULY ALIVE, ALL THAT THE PERFORMER IS CREATING AT A CERTAIN MOMENT. THE DUENDE RESEMBLES WHAT GOETHE CALLED THE 'DEMONIACAL.' IT MANIFESTS ITSELF PRINCIPALLY AMONG MUSICIANS AND POETS OF THE SPOKEN WORD, RATHER THAN AMONG PAINTERS AND ARCHITECTS, FOR IT NEEDS THE TREMBLING OF THE MOMENT AND THEN A LONG SILENCE."
>
> —*FEDERICO GARCIA LORCA, IN SEARCH OF DUENDE*[†]

The Greeks introduced the nine Muses to describe where artistic inspiration comes from. The Spaniards had a more direct approach.

The magic that Flamenco creates is defined two ways:

1. It's an emotional/physical response to art.

2. It's also an elf

Wait! Come back! You can't use logic or cynicism to elude *duende*! It will find you, it's impossible to hide!

The Gypsy fable goes something like this: when the perfect scene is set, there are spirits from a magical place that can cross over to our world and when they come you can feel it as a kind of electricity in the air. They can make mischief. They also make magical connections possible. These Djinn or fairies come "through the eyes" when you see great art or beauty and link you to the divine. But they only come when many eyes are seeing the beauty. They come for shows.

Duende is the Spanish word for seeing God through the beauty of show.

Maybe *duende* is some of these things:

- The insanely complicated feelings of first time poet-performer as they read their words from memory to a crowd of 400 people: risk, vulnerability, excitement, approval, crippling self-doubt and surrender.

- Or how a matador does a dance with a bull that is so impossibly beautiful the Moors would point and yell "God!"(*Allah!* with a Moorish accent is pronounced *Olé!*)[†]

- When you see an opera singer hit a super high note, and hold it with passionate resolve and the hair stands up on the back of your neck: that's more than years of vocal lessons. The lights, the props, the smoke machine, the acting, the audience...it's a ritual that summons *duende*, of course.

- The sleeper who kills it at karaoke. Just nails it, you didn't see that coming. It was like a magical little elf possessed him or something!

- Moshing to *At The Gates* with a thousand other metal heads when they extend the intro to a song to just one note crunching in 4/4 time. The meanest, evilest sounds at an ungodly volume and surrendering to total catharsis. And feeling perfectly safe, totally free and holding bloodlust as your body becomes one with the music as it flies through the air, knowing you won't be able to count the bruises tomorrow. And not caring.

- You've got $500 on the table. The craps table is packed. You shake the dice and let them fly! Time slows down as they hit the table, the air is thick, excitement is high... it kinda seems like it's the same thing...what is that? I honestly don't know. I have to think about that...

- The feeling as the car pulls away from the curb departing on a road trip with dear friends with no destination. That magical energy in that car, playing that music at that volume everyone screaming the lyrics and feeling free and full of possibility.

- The magical aura of a glowing bride, surrounded by the love of family and friends...flowers on the ground and everywhere, festive decorations, endless feasting and wine...tell me the elf can resist that shit, no way!

- It's the last 2 laps of the Indy 500, there are 2 cars battling for the prize way out front and the car in back does the 'slingshot' and catches the front car unawares and zooms to victory!!!!! No, that's not really it actually. There's no *duende* there...*or is there*?

"THE NOTION OF *DUENDE* (FROM DUEN DE CASA, "MASTER OF THE HOUSE") CAME TO [LORCA] FROM POPULAR SPANISH CULTURE, WHERE *THE DUENDE* IS A PLAYFUL HOBGOBLIN, A HOUSEHOLD SPIRIT FOND OF HIDING THINGS, BREAKING PLATES, CAUSING NOISE, AND MAKING A GENERAL NUISANCE OF HIMSELF. BUT LORCA WAS AWARE OF ANOTHER POPULAR USAGE OF THE TERM. IN ANDALUSIA PEOPLE SAY OF CERTAIN TOREROS AND FLAMENCO ARTISTS THAT THEY HAVE *DUENDE*—AN INEXPLICABLE POWER OF ATTRACTION, THE ABILITY, ON RARE OCCASIONS, TO SEND WAVES OF EMOTION THROUGH THOSE WATCHING AND LISTENING TO THEM."

—CHRISTOPHER MAURER, IN SEARCH OF DUENDE[†]

When you get these magical moments, this *duende*, an odd thing happens. You have to pretend you don't notice, or you will dispel the magic. But time slows down. Vision comes into better focus. A kind of lightning lingers in the air like ozone. This is the domain of goose bumps as you are spellbound and ALWAYS fully present in moment. This is the place of transcendence. You are brought here by inspiration and drawn away by fear or doubt. Trying to even write this down makes me feel like a traitor, but I really feel like we have to cheat at least a little because shits kinda going crazy out there. We have to survive this technological adolescence we are going through and not lose all of the wisdom and connections to things that aren't machines now that we have them doing so much for us. We need to remember that cultures in the past lived for *duende* and other art forms, and worked only to eat and survive.

> "THE MUSE, THE BELOVED, AND DUENDE ARE THREE WAYS OF THINKING OF WHAT IS THE SOURCE OF POETRY, AND ALL THREE SEEM TO ME DIFFERENT NAMES OR DIFFERENT WAYS TO THINK ABOUT SOMETHING THAT IS NOT ENTIRELY REASONABLE, NOT ENTIRELY SUBJECT TO THE WILL, NOT ENTIRELY RATIONAL."

> **—EDWARD HIRSCH, THE DEMON AND THE ANGEL[†]**

Whoa Nelly!!!

> "WHOA WHOA WHOA, *DUENDE* IS VERY CHARMING, CHICKEN, BUT HOW DO WE GET FROM DOING SHITTY BASEMENT SHOWS AND LIVING YOUR LIFE AS ART TO TRANSCENDING GOVERNMENT AND CREATING GLOBAL UNDERSTANDING? AREN'T YOU BEING A LITTLE GRANDIOSE? A LITTLE TOO SELF-IMPORTANT THERE, CHICKEN JOHN? YOU'RE JUST ONE LITTLE GUY, YOU ARE NEVER GOING TO HAVE ANY EFFECT ON WORLD MARKETS! I MEAN, YOU WILL BE LUCKY IF YOU SELL 5,000 OF THESE BOOKS OVER THE COURSE OF YOUR LIFE."

> **—YOU, THE READER**

One of the systems that is easiest to see is parallel evolution. It's like a natural law. If you are doing something, or thinking something or evolving towards something, you can bet your sweet bippy that there are other people doing it as well. "There is nothing more powerful than an idea whose time has come." Victor Hugo. Whatever we do, in five years they are doing it in Atlanta and seven years it's in Hanoi. We, the artists, are on a world stage, the world is watching what we are eating, what we are doing and the world is listening to what we are saying. The world is watching our videos. And those motherfuckers are totally copying everything we do. The trend has been that EVERYTHING we do proliferates on a global scale. Our fashion, our politics, our ethics...everything. This book isn't *the* book. It's *a* book. If I'm the only guy writing this book, it's a curious thing. The ideas that I see as inevitable will shake out another way. But the amount of parallel evolution I've seen in my life tells me that it's basically impossible for me to be writing this book without 50 other people also writing their version. That's just how this kind of stuff works.

The solutions are in knowing systems. That I have seen over and over again. Macro. Micro. I see it now. Not 100%, but I see it. Things are better. War, poverty, geno-cide...all that stuff *statistically* is down. Body counts, colonialism, female circumci-sion...all that is down. But freedom, surveillance and liberty in the past 10 years are in decline. Do I dare make a Failgraph for Capitalism?

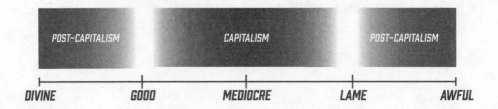

See, it's the same system as a Fiction Show/Severe Comedy show. The risk that *HAS* to be present is the thing that we see in our government when Virginia lawmakers say that transgender people can't use a public toilet or when Putin puts Pussy Riot in jail. The world *could* devolve into a fascist run slave-state for those eighty-two billionaires who have half the world's wealth, or it could evolve into the post-money socialism of Star Trek. The stakes literally can't be higher. The best capitalism and our two party system can ever do for us is mediocrity. Post-capitalism will pass or fail because of the cultural system I talk about in the next chapters.

No shit!

Movement of Movements

Let me ask you a question: what movements do you belong to?

That may seem like a strange question, but I bet at least half of you have an answer right on the tip of your tongue. You love to talk about it. You were hoping I'd ask. Another 30% of you have a good answer once you've thought about it for a moment. Another 20% of you are lying. The remaining 15% of you are just lazy.

I know that's more than 100%. I told you, bad at statistics. But I'm right.

In fact, I could probably ask you an even more specific question: what movement brought this book to your lap?

Movements have been around since the first human beings decided that they liked campfires. There was the campfire movement, the cave painting movement, the 'let's hunt in packs movement'—that was huge. Freaked out all of the gatherers. History is full of people belonging to movements, and most of them were stupid and a lot of them changed the world. But these days everybody's in a movement. Or two. Or twenty two. It used to be most people didn't have a movement, they had identities, and life was pretty monotonous and kind of miserable. Some people had 'a' movement, but that was usually it. That was their thing. They didn't have time to be doing more than one. If you were juggling multiple movements you were some kind of genius. A polymath. Like Gottfried Leibniz. I think. I just asked my Facebook friends to name a historical polymath and his name came up. But that's the point: the better and faster our communications technology, the easier it was for movements to reach us, and for us to reach them. The internet has made connecting with new people and ideas so easy, and the barriers to membership so low (Just click 'LIKE!') that we're almost in a competition to see who can belong to the most movements.

People who like to protest stuff are the worst cases: do you know how many rallies I've organized where the protesters can't stay on topic, because choosing just one thing to protest about is like letting all their other children starve. Yes, they want to stop the privatization of Dolores Park, but they also want to stop the evictions! And promote solar energy! And criminal justice reform! I'm just as bad, but mostly people don't notice because they're too focused on the novelty vomit I've asked them to leave all around the park. It's a long story...

But I'm not really making fun of them. Okay, I am, but...no, there isn't really a 'but' there, I guess. It's funny! Come on, it's funny. But I'm not shaking a stick at them saying, "You kids and your movements! Get off my lawn!" Because the kids are right: they have to walk on the grass. The way that everybody's got so many movements is actually a really important thing. Everybody may be marching to the beat of a different drummer, but they're all marching in the same direction.

But first, maybe we need to:

DEFINE A 'MOVEMENT'

What's a movement? Do you know it when you see it?

Is the Civil Rights Movement a movement? Of course! It has 'movement' in the name! Come on, you're not trying.

But was the TV show, *Roots*, a movement? Was it part of the Civil Rights Movement? Were the producers part of the movement? The camera men? The people at home watching it? Was the reboot part of a movement? Was it the same movement?

Was Rock and Roll a movement? How about Elvis impersonating?

Are video games a movement? Is the push for virtual reality games a movement? Does that mean everybody who plays Pokemon Go is part of a movement?

Is Christianity a movement—or is that just believing in something? Does it matter which church you attend? Is Atheism a movement—or is that just not believing in something? Does it matter which church you don't attend?

How about the 'sharing economy'? Air BnB's marketing program? Is that a movement? (hint: no, it's a marketing program)

Is the internet a movement? Was radio? Were newspapers? If you could find a newspaper today, would it still be a movement? What do people with birds do now that there aren't any newspapers?

Is Harry Potter a movement? How about the Lord of the Rings? Superheroes? Are Superheroes a movement? Comics?

What about people who ask rhetorical questions? Are they part of a movement? A very annoying movement? That goes on forever?

You get the idea.

Defining stuff is not my idea of a good time. There are a lot of things I'd rather be doing. But the difference between a movement and something pretending to be a movement is really important. I don't mind if something's not a movement, but sometimes it makes my skin crawl when something that's not a movement pretends to be. And I bet, once we go through this, you'll remember a time you had the same feeling. You knew something was wrong, you knew it was giving you the 'get it off me' feeling and you wanted to tell these damn kids to get off your lawn, but you couldn't figure out why. I bet this is why.

Because what we're trying to do is separate out 'movements' from 'entertainment', 'fads' and 'fashion' and other elements of consumer culture. Which is tough because sometimes entertaining or fashionable things can turn out to be movements, but movements never turn out to be <u>only</u> entertainment and fashion.

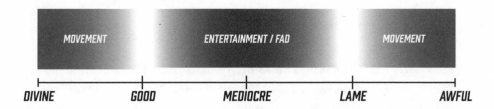

Try this: there is no way you say to Miles Davis as he walks off stage: 'That was very entertaining Miles. Totally worth the $24 I paid to get in.'

Some characteristics make something more likely to be a movement than entertainment or a fad. Or just straight up marketing a product.

Is it something people:

· People attach their identity to?

· Obligates them to action?

· Fills a void in their lives?

- Brings them together in fellowship?

- Seeks betterment for the self or the world?

- Embraces art outside of commerce?

- More ways to relate than consume

- And it has a justification and a purpose that defies MERE ENTERTAINMENT.

If so, it's either a movement (or pretending to be).

What I'm saying is, these are good things to watch for, but they're not sure things. People attach their identities to all kinds of weird stuff. Sometimes it's creepy. People come together in fellowship over pure bullshit: The Dadaists were definitely a movement, but the Barbie Collectors' Convention? Not so much. And sure, embracing art is great—but pure entertainment and fashion (and a lot of fads) sometimes claim to do that too.

Munificent dispensations

LET'S STRETCH 'IN FELLOWSHIP' AS FAR AS WE CAN, SHALL WE? LET'S STRETCH IT TO THE ENDS OF THE EARTH! LET'S SAY YOU WANT TO DO THE NHAM NHÍ CHANT. FINE. DID YOU KNOW THAT THERE IS A MONASTERY IN VIETNAM WHERE THERE IS ALWAYS SOMEONE DOING THE NHAM NHÍ? THERE IS A GUY THERE, RIGHT NOW. CHANTING THE NHAM NHÍ. SO, LET'S SAY YOU ARE IN ALASKA AND YOU ARE FEELING LONELY. YOU CHANT THE NHAM NHÍ IN FELLOWSHIP. MONKS ARE COOL LIKE THAT. ANOTHER EXAMPLE THAT THE WELL OF COMPASSION WE DIP OUR LADLES IN IS ENDLESS AND COSTS US NOTHING. LET US BE MUNIFICENT AND PRODIGAL WITH OUR DISPENSATIONS.

So what's the thing that really makes a movement a movement?

It's actually pretty simple.

A movement is something that you can relate to in ways beyond consumption and entertainment. And it's not a tool. For example, Facebook is not a movement. It's a communication tool.

That doesn't mean it's not important, or cool, or worth doing, or even educational and mind-blowing. Just because a thing's not a movement doesn't mean it has no value. But to be a movement, in the sense that I mean it here, it has to engage people in ways that go beyond commerce and entertainment even if there is a commerce exchange and it's *also* entertaining. It's tricky.

Sometimes that's gathering people together—absolutely—but not if you're basically getting together to be entertained (like going to a bar to watch *Orange Is The New Black* on their big screen) or to buy stuff at a mall. I'm not going to pretend to sit in judgment over every convention and event, but I don't have to. Red Lobster doesn't cut it as a culinary art. It's just eating. A Ford Taurus is never going to be 'a classic.' No one ever got to *duende* doing the Hustle.

But when something starts inspiring people to engage the world in other ways? To meet their neighbors, to start a soup kitchen, to play a musical instrument, to run candidates for office (for reasons that aren't "I need my industry to get a tax break"), to invent things, to consume less, to change how you relate to people, to contribute some fun to a festival…this is how a movement starts.

If you're starting to see the connection between movements and *duende*, good job. I commend you on your resolve, this is about the point that I'm afraid people are going to start skimming. But not you. You're my favorite one!

And let's stop using *duende*. It's so serious. Let just say "*TA* DA!" from now on, OK?

Now sit down. We have work to do.

These days, everybody I know is in 20 movements. Or thinks they are. Sometimes they're in entertainment or consumption fads pretending to be movements. Do you see how they can try to fool you? And why it feels so creepy when a fashion or fad that is really only asking you to be entertained and buy stuff claims to be a movement? Pretends to fill a void in your life? Keep in mind that 'pretend' movements can totally be mediocre. Especially here at 'peak advertising.' It's horrible. It's a black hole of desperation and need that never really gives anything back, but it's got a shiny gloss. A fancy paint job. Probably pretty girls standing next to it smiling. Brrrr.

Whether or not the people I know are in real movements doesn't matter. Well, I mean, it matters. For them. To their lives. To their sanity. But the important thing for what we're talking about is that these days everybody is looking for as many movements as they can get. Even if they're fooled, they're fooled because they're *looking*. If all you want to do is sit around and enjoy the way things are, you don't have to go looking. But some people are: they're looking for something beyond mere entertainment and marketing and consumption. They're seeking. Experimenting. They're looking for things that the world as a machine can't offer. Only the world of magic can. And they want it bad.

They just don't know how to make that switch—because it turns out just *joining* a movement isn't enough. You can't just sign a petition and wear the t-shirt and go to a rally and sit in a drum circle. That's all great (if you like drum circles), it's a start, but it's not usually going to get you where you want to go yet.

a rally and sit in a drum circle. That's all great (if you like drum circles), it's a start, but it's not usually going to get you where you want to go yet.

What else has to happen?

We'll get back to that. We will. That's, like, the point of this book, that question. But first let's take a closer look at this weird land of 'movements' and 'not-movements' and 'consumption disguised as movements' and 'movements disguised as consumption and entertainment.'

Like 'micro-movements.' Have we talked about micro-movements yet? Oh, that's important. Here, I'll write it really big and important-like:

MICRO-MOVEMENTS

I joined the punk movement pretty young. It was the only relevant thing available to me in 1980. For all my young years, that's the direction my molecules were pointed. Rock was the windmill we all tilted at. But there were other things affecting culture. Like hip hop. But hip hop was playing the same game that rock was. You had to be good. You had to rise to the top. Your content had to be worthwhile. You needed connections to get your music heard, then you needed a record deal. Hip hop fashion as well. You needed to be in the magazine, have your line, be connected. Punk bypassed all that shit. You just did your thing and there was an automatic audience of people who could care less if it was any good. Tens of thousands of people who would come to your show, buy your shit, feed you peanut butter and jelly sandwiches and let you sleep on their floor. But we'll get to punk later. I mean, these are kinda brutish things to say: "The culture that I contributed is the only relevant blab la la." And I'm willing to take some lumps. But that's the truth and I wish I could have that concept corroborated here from people smarter than me but when I went to cite the sources they were really hard to find. I was looking for ways that I could show you how micro-movements started. How ideas became specialized and boutique. But it would take another book to do it.

Boutique Ideals Boutique Ideas

Born male but don't feel comfortable about it and don't wanna be female? Come up with your own gender. Everyone is happy to play by your rules. Like reggae but don't like vocals and it has to be in ¾ time? There are four dj's on Soundcloud doing that. Like 97% of Libertarian politics but you think food stamps are OK? Reddit group ready to count you as member number 273. There are endless examples of people fine-tuning reality to meet their specific needs. Voluntary combinations define ownership in these micro-movements. I'm sure you're getting that, but sometimes I

What's the difference between 'Rock and Roll' and 'Metal.' And then between 'Metal' and 'Death Metal' and 'Heavy Metal?'

I don't mean as music, I mean as movements. And they are each movements. It's entirely possible to say "I live a rock and roll lifestyle" and have people know what you mean in a way that goes beyond just listening to the music and buying the clothes. (It's also totally possible to be a poser who just likes to dress 'rock and roll,' but, I'm never going to promise you we can eliminate posers. I don't have a book in me for how to do that. No one does.)

Do Rock and Roll kids respect authority? No! No they don't! They cut classes and make-out at parties and do all the drugs and drive fast and you can't scare them by saying, "that might kill you!" Or at least they did, until it all got co-opted...which is when a movement gets reduced to consumption and entertainment and there's no longer any difference between people who are faking it and people who aren't.

...that sentence? Right there? That's like the tragic story of 20 years of my life. In one run-on sentence. God it's depressing. I never thought I'd see the day when Rock and Roll, punk and hip hop turned mainstream. When I was on stage with GG Allin watching him throw shit into the audience, everyone there was thinking, "We'll be counter-culture FOREVER!" When I say, "I've made all the mistakes,"I'm not kidding...

Likewise, if somebody's hard core into metal, they don't just like the music, they've got a whole way of looking at life and making decisions that is represented by, and inspired by, but not limited to, the music.

But while 'metal' is kinda sorta a kind of 'rock and roll,' while they're related as art forms, what's the connection as movements? What's that relationship?

Or the relationship between 'Sci-Fi' and 'Star Trek' and 'Cyberpunk.'[3] They're all movements, right? And they're all related, right?

Sure, but how does that work?

3 Sci-Fi can have actual magic, Star Trek and Cyberpunk can't!

This is the difference between 'movements' and what I call 'micro-movements.' It's possible for a movement to become banal and stale, and to breathe new life in it, micro-movements come out. A Movement is often usually something so big that it's really impossible to get your hands on it, let alone your brain around it. Civil Rights. Rock and Roll. Science Fiction. Democracy. There will never be a definitive history written about them, because it's just too big, with too many people, and even if it could all be contained in one place, you'd never get through it. Especially not if you wanted to, you know, participate in the movements. That takes time.

But every movement like that ends up inspiring a lot of small, more manageable, kind of boutique or niche movements. You see? If Science Fiction is a movement, Cyberpunk is a micro-movement. Waaaay easier to get a handle on. And with a clear connection, and relationship.

Let's take a look at some specific examples of movements and micro-movements, beyond me just mouthing off about civil rights and gender.

How low can a p<u>un</u>k get?

OK, so no one does this. So I'm gonna do it right here, right now. I'm going to define Punk Rock. Punk is a term that refers to a person who is a sub-human. A prostitute, or a protected prison sex slave. A second class citizen. Lenny Kaye[†] was the first person to refer to a kind of music as 'Punk Rock,' implying that this new genre of music was different, yes. But also that it was worse. It was perfectly stated. That the movement itself embraced the term Punk Rock speaks volumes. It was self-deprecating proof that the punks could care less what society thought of them and in fact, would prefer they were hated and excluded. You will see how this makes all the difference in a moment.

Like the Branch Davidians, the Quakers, and the Amish, the punks wanted to be left alone. We wanted to be separate. We had our own shows, we never had one punk band on a bill with other rock acts. Never. We did everything we possibly could to alienate and distance ourselves from everyone else. It was a secret society. A real, actual secret society. Our music was hidden in record stores in a section called 'imports.' Even domestic releases of punk were found there, in Record Bar and Peaches. We would put and find flyers for shows there in between the records, like maps to buried treasure. Enough people made fanzines that there were libraries. But we were so few! We were a dollop of the aggregate of general society and we spent a lot of energy keeping ourselves separate. To keep the straights out. We were pirates, building utopia. Man, that did not work at all.

We weren't advertising DIY culture. I mean, we were with our zines and our records and our fashion. But we weren't proselytizing. We weren't selling. And because we weren't selling, people had to just be able to see and be transformed. And they were.

Punk rock fucking won. Totally won. Hands down. The victory of the Punk movement was so complete, so absolute, that it changed not only the music industry but EVERY cultural institution.

What was so great about punk, anyway? How could something that was named after a second class citizen topple the centers of civilized artistic powers and become the Pandora's box of culture?

Content. And no, not that the content was good. It wasn't. It was that it could be awful, and know it. And it didn't matter. As long as it wasn't mediocre. That was the victory of Punk. We couldn't be stopped. We didn't care about consequence, we self-inflicted more than anyone else ever could foist on us. Our writers made their own books. Our musicians made their own records. Shabby was chic. Conspicuous consumption was off the table. It has taken 35 years for the DIY aesthetics to get to philanthropy, but there are rumblings now. Mega-charities like the Gates Foundation are seeing some critics asking why doesn't Microsoft just make its products cost less? Yea Bill? We wouldn't need your handouts if you weren't bilking us![4]

Anyway, somehow, people 'got it.' Outside of words or manifestos or books. What, exactly, did they get? Magic. They saw it. All of it. Whatever they were doing before finding Punk Rock probably wasn't creating *TA da!* moments. What they had, what we were separating ourselves from was: sterile commercial music, expensive clothes that a million other people were wearing, consumer culture, everything calibrated to money and lame sex partners. I mean, why wear clothes every day when you can wear a costume? Why listen to background music? Tradition meant nothing. We had a clean slate and didn't have to compromise anything. You're alive, you know what we did. It became so prevalent, it didn't change culture, it BECAME culture. What was once punk street cred is now just cred. What was once a badge of honor (having every Clash album) is now just called iPod. XTC plays in McDonald's. I heard Agent Orange while I was on hold with AirBnB.

Punk was a movement that incorporated multitudes of micro-movements. And they were full of contradictions. For example, staunch Republican Johnny Ramone said, "God Bless George Bush" when he accepted his trinket at the Rock and Roll hall of fame, but Jerry Falwell's 800 number was called so many times by Punk Rock activists that they had to take it down (it supposedly cost over $800,000 in calls!) There were right-wing skinhead bands like Screwdriver, Libertarian art rock bands like F or XTC and super liberal bands like Reagan Youth or MDC. You had full-on hippy values with Crass, anti-political groups like Black Flag and the anti-consumer message band X-Ray Spex. It was all over the map. It's a perfect example of a movement and within it, many many micro-movements: Riot Grrrl, zines, straight edge, college radio, Krishna-core...the list is amazingly long. All things that are things

4 The Gates Foundation is the result of Microsofts' domination of a market using a mechanistic system that could give a shit about people, all it wants is profits. Then, they give 36.7 billion dollars of the profits away as charity?[†]

unto themselves, but also related to a larger more general movement with TONS of crossover music and ideals. And tons of experiments in utopia building. Let me give you an example:

California dreaming...

924 Gilman Street opened in 1985. When it opened it was an all-ages, members-only music venue for punk/hardcore shows. I was 17 and living in NYC. The people that opened it were the people who did *Maximum Rock and Roll* magazine here in SF. I wrote for the mag on occasion doing the NYC punk scene report. It was the first writing I ever did and it was read by tens of thousands of people. Very cool opportunity. I wrote that report on and off for a few years. I owe those people a debt I can never repay.

The booking policy when 924 Gilman first opened was wholly different than any other performance venue I've ever heard of before or since. Instead of advertising who was playing there this weekend using flyers or mailings or ads in newspapers, they forbade ANY promotion. No flyer. No ads. No one was to know who was playing. It was a secret. Tell me that didn't create some *TA da!* moments. You literally had no idea. Some of the bands would set up their stuff and before the first song would announce who they were, "Hi, we're Wasted Youth from Orange County." Sometimes they wouldn't say anything. And we didn't really know what people looked like. So they'd kick into their first song and it was like "Holy shit, it's Marginal Man!" or whoever. I lived in NYC, so I only came out a few times, but you can imagine the magic. It also made for some serious balance. Usually, when Operation Ivy played, the place was packed to capacity and then some. When local bands played, you were lucky if 40 people were there. But with no marketing allowed, you were more apt to take a chance. And I'm sure a lot of people who went and saw local bands were delighted. It was a way of putting people on the stage with no baggage and creating a ton of mystery. It totally changed the way I thought about shows forever.

Transformational festivals

There's an event in Southern California called Lightning In A Bottle. The first year I went was the second year it happened. I filled the Applause Bus with 25 clowns from Kinky Salon and towed my gasified truck to do demonstrations. Comparatively, it was tiny when you see what LIB is today. The people that went to that festival in 2007 were a community of folks I didn't really have any access to. Curious, I went back for six more years. All the time thinking to myself, "This is a movement, right?" I just wanted to be part of it or see it or something. It happens early in the year, like May, so I was able to go every year without it pushing against Camp

Tipsy. And I did watch it grow. And it was kinda horrifying, kinda cute, kinda baffling. I mean, it went from a thing that was volunteers and community and fun to a four-million-dollar operation and 20,000 people.

I called it Leather/Feather. Complex crazy fashions on offer from dozens of vendors, nothing under $240. Stall after stall of handmade creations of sacred geometric designs, wind chimes made of bird bones and the most ornate 1930's fanny packs you have ever seen. For $800. Yoga fashion. Full Native American headdresses. Lots of wings: Fey, bat and dove. (Seriously: real dove feathers woven into giant wings). Giant headpieces with peacock feathers—those things had to be seven feet wide. Doeskin loincloths. Fancy assed fucking boots. Jewelry forever. Every hat from every Charlie Chaplin movie. The feather thing really struck me. Like, whoa. If the feather thing catches on as a fashion trend, birds everywhere are fucked. In the early day of Burning Man, we fought for no commerce. The LA kids built a mall in their festival.

I kept asking myself, "Is this a movement?" I actually brought Benjamin Wachs down to LIB in 2012 to ask him that exact question. I wanted to ask him at the event. So I brought him there, and I asked him.

"Nope," he said. "This is not a movement." He was right.

That particular event in-and-of itself is absolutely not a movement. But it totally is part of the micro-movement of 'transformational festivals' that is totally changing the cultural landscape in significant ways[†]. In fact, that moment was when I realized that micro-movements are a thing. And LIB is in very good company.

'Transformational Festivals' are a micro-movement of events where you go to a festival environment and have your consciousness raised and walk the path of the spiritual warrior. Or something. Also, you can get your chakras realigned, listen to ethnic chanting from thirty different culture burlesques, see tons of art made of sacred geometry, eat shitty vegan food, listen to the didgeridoo around a fire and generally see a lot of people exploring and seeking and trying to re-connect in a bunch of the 'old ways,' For better and worse.

Spiritual consumerism is just people not getting it. It's not a new thing. Chogyam Trungpa brought Buddhism to the west in 1970. Three years later he published *Cutting Through Spiritual Materialism*. That didn't take long. I mention it here because this problem in Buddhism is mechanistic in nature. In the next chapter we will outline systemic failure for art groups, but it's easy to see how the confusing paradox of being both American and Buddhist is going to take a lot of work. Buddhism is about letting go of fear. Americanism is about the fear of not having enough. It's kinda funny when you think about it.

Transformational festivals are absolutely NOT my cup of tea, but just because they are easy to make fun of doesn't mean that they aren't awesome. Even if you detest the content (or love to make fun of it) the people who go to these things are idealistic seekers looking to make a difference. Like most other movements, they have attached because they see a clear path to bettering themselves and the world. I recommend you spend as much time as possible surrounded by people like this. Much of my chicanery is sarcasm, not cynicism. Big difference. A great way to explain the benefit of bringing your body to festivals like this is with an examination of how we relate to people. At transformational festivals, you have a better chance of having an 'I-you' relationship with people than elsewhere. Maybe.

1930 MARTIN BUBER, GERMAN JEWISH MYSTIC, DEFINED RELATIONSHIP IN A WAY THAT HAS BEEN ADOPTED AND REVERED. IT'S TRICKY TO GET YOUR HEAD AROUND AT FIRST, BUT IT'S WORTH THE CLIMB. THE VIEW FROM THE TOP OF THIS IDEA IS BREATHTAKING.[†]

I AND THOU: SEEING GOD IN EVERYTHING IS A MATTER OF FOCUS. IT IS THE PREMISE THAT THERE CAN BE NO SELF WITHOUT AN OTHER. BUBER SAYS THAT THE CONCEPT OF 'I' COMES INTO EXISTENCE IN THE RECOGNITION OF 'YOU.' AS 'UP' IS A MEANINGLESS CONCEPT WITHOUT 'DOWN,' SO 'I' IS UNCONCEIVABLE WITHOUT 'YOU.' HE DESCRIBES ALL OTHER RELATIONSHIPS AS 'I-IT.' THIS SECOND DESCRIPTION REPRESENTS A LIFESTYLE OF CONSUMERISM. THE WAY TO REDEMPTION IS THROUGH ENCOUNTER WITH THE DIVINE IN ONE'S DAILY LIFE THROUGH THE 'I-THOU' MODE OF EXISTENCE.

SIMPLY PUT, 'I-YOU' IS HOW MARTIN BUBER DESCRIBES SEEING GOD THROUGH OTHER PEOPLE.

THE PROBLEM IS THAT 'I-YOU' RELATIONSHIPS, AS BY BUBER, DO NOT HAVE A GRADIENT. YOU CAN'T HAVE A 'MORE' OR 'BETTER' 'I-YOU' CONNECTION WITH A PERSON, SAY, AT A TRANSFORMATIONAL FESTIVAL THAN YOU COULD, SAY, IN LINE AT A MARKET. THERE IS OTHER EVIDENCE THAT BUILDS ON THIS WORK AND EXPANDS IT WITH A GRADIENT.

IN A TRIBAL OR RELIGIOUS SETTING, UNIVERSITY OF CONNECTICUT ANTHROPOLOGIST DIMITRIS XYGALATAS TELLS SCIENCE OF US, A SHAMAN WOULD HAVE CARRIED PEOPLE THROUGH ECSTATIC EXPERIENCES, BUT TODAY THAT'S THE ROLE OF THE DJ (OR ROCK BAND OR SOCCER TEAM, DEPENDING ON YOUR ENTHUSIASM).

XYGALATAS HAS ADDED EMPIRICAL WEIGHT TO COLLECTIVE EFFERVESCENCE. FOR A 2011 PAPER, XYGALATAS AND HIS COLLEAGUES WENT TO A GREEK VILLAGE WHERE FIRE-WALKING HAS BEEN

PRACTICED FOR CENTURIES. HE RIGGED BIOMARKER TRACKERS TO VILLAGE PEOPLE ON THE NIGHT OF A FIRE-WALKING FESTIVAL, WHERE THE EMPEROR-SAINT CONSTANTINE IS SAID TO POSSESS FIRE-WALKERS AS THEY DANCED ACROSS HOT COALS. THE RITUAL WAS 'EMOTIONALLY ALIGNING' FOR THE ENTIRE COMMUNITY, AS INDICATED BY HEART RATES. VIEWERS SHARED HEART-RATE SYNCHRONY WITH THE FIRE-WALKERS, AND THE PEOPLE WHO WERE SOCIALLY CLOSER WITH THE FIRE-WALKERS—RELATIVES AND FRIENDS—HAD GREATER SYNCHRONY. THAT'S WHY, XYGALATAS SPECULATES, IF YOU SPEND THE WEEKEND AT A MUSIC FESTIVAL, THE ACTS THAT YOU IDENTIFY WITH WILL SPRINKLE YOU WITH THE FAIRY DUST OF COLLECTIVE EFFERVESCENCE WHILE THE ONES THAT AREN'T PART OF YOUR IDENTITY MIGHT LEAVE YOU DISCONNECTED, UNSYNCHRONIZED. FOR XYGALATAS, A LIFELONG FOOTBALL FAN, BEING AT THE STADIUM FOR HIS HOMETOWN TEAM IN GREECE MAKES HIM FEEL ELECTRIC, BUT HE CAN GO SEE A BARCELONA MATCH AND OBSERVE THE MAJESTY OF THE TEAM AND TRADITIONS, BUT HE WON'T GET GOOSEBUMPS. 'RITUAL IS A SOCIAL TECHNOLOGY,' XYGALATAS SAYS. 'THERE'S A COMMUNICATIVE ASPECT, BUT ALSO A PRIMORDIAL, INSTINCTIVE ASPECT: TO FOLLOW RHYTHM, BE DRIVEN BY IT.'

FRENCH SOCIOLOGIST ÉMILE DURKHEIM ON 'COLLECTIVE EFFERVESCENCE.':†

"EVOLUTIONARY PSYCHOLOGISTS SPECULATE THAT MOVING RHYTHMICALLY TOGETHER WAS A WAY FOR EARLY HUMANS TO BOND AND COMMUNICATE WITH ONE ANOTHER. WHAT CONTEMPORARY AMERICANS REFER TO AS 'PARTYING' IS OF A PIECE WITH WHAT FRENCH SOCIOLOGIST ÉMILE DURKHEIM CALLED 'COLLECTIVE EFFERVESCENCE.' ACCORDING TO DURHKEIM (AND SO MANY SNAPCHAT STORIES), WHEN PEOPLE START MOVING IN A SHARED, DIRECTED EXPERIENCE, A CURRENT OF EXCITEMENT STARTS PULSING THROUGH THEM. IN HIS OVERVIEW OF DURKHEIM'S WORK, UNIVERSITY OF MONTREAL RESEARCHER PAUL CARLS WRITES THAT 'THIS IMPERSONAL, EXTRA-INDIVIDUAL FORCE, WHICH IS A CORE ELEMENT OF RELIGION, TRANSPORTS THE INDIVIDUALS INTO A NEW, IDEAL REALM, LIFTS THEM UP OUTSIDE OF THEMSELVES, AND MAKES THEM FEEL AS IF THEY ARE IN CONTACT WITH AN EXTRAORDINARY ENERGY,' ONE THAT LEADS TO A 'HIGH DEGREE OF COLLECTIVE EMOTIONAL EXCITEMENT OR DELIRIUM' FOR PARTICIPANTS. TO DURKHEIM, COLLECTIVE EFFERVESCENCE IS PART OF HOW A RELIGION TAKES WING, AND IT'S PALPABLE IN THE PROSTRATIONS OF MUSLIM DEVOTEES, THE CHANTING OF BUDDHIST MONKS, OR THE SHARED 'PRAISE HANDS' OF CHRISTIAN EVANGELICALS. IN SECULAR SOCIETY, THE EFFERVESCENCE HASN'T BEEN EXTINGUISHED; IT'S JUST BEEN TRANSMUTED."

There are dozens and dozens of these transformational festivals. It seems like an impossible task to count them. They start off really small, and some of them get huge. With a cursory look on the web without devoting a bunch of time I found eighty events that voluntarily referred to themselves as transformational festivals.

There is a calendar with links.[†] A circuit that the vendors do. It's a thing. Fire spinning. Yoga. Classes in permaculture and adobe house building. Light shows that are beyond anything your average Rolling Stones fan has ever seen. Sound bath. Monkey chant. Sacred crystal bullshit. Tea houses. And some of the worst music that you have ever heard. All of it is akin to the soundtrack of a video game. Blips and bleeps and this crushing 808 kilohertz downbeat in 4/4 time. In perpetuity. The same song. For days on end.

OK, so I'm a dinosaur. At least I'm consistent. The point is that festivals are a movement and transformational festivals are totally a micro-movement, and LIB is one of them. You wanna pick another kind of festival to talk about? Digital detox retreats? Film Festivals? Carnival? Food? Art? Music? OK, what kind of music? Reggae? Tweak? Shoegaze? Wikipedia tells me there are 150 kinds of Electronic Dance Music. Bluegrass? Klezmer? Oompah? How about we talk about Beach Goth?

Beach Goth

Four years ago, I declared that Thursday night of Camp Tipsy was Goth Night. C'mon, Goth Camping. What does that even mean? Two things that couldn't possibly be more disparate. Or so I thought. Last year I found out about Beach Goth. Which is totally a thing. There is a festival in Orange County that tens of thousands of people go to. Vice did a video piece on it.[†] Someone going around asking everyone in elaborate, homemade costumes, "What is Beach Goth?" And not unlike my Goth Night at Tipsy, people couldn't really answer. But the way they couldn't answer was totally telling. The way they didn't answer wasn't that they didn't know. They just weren't talking. If you didn't 'get it,' then maybe you're just not ready. Zing! "You're not evolved enough to play on our level," implied the guy in the Elvis outfit with the Frankenstein make-up. Two girls dressed like Can-Can dancers said they didn't know but didn't care. It was great. Can that be a movement, when the people don't even know what the fuck it is? In Orange County? Yes. In NYC, no way.

Vogueing

Vogueing. Before it was ripped off by Madonna, it was a micro-movement. And it's totally cool. Madonna scratches the surface. The film *Paris is Burning*[†] does a great job of showing what a complicated combination being Latino/African American, a New Yorker, male, gay and yearning for the magic moments that only a show can bring. They called it Ball or Ballroom. It was cool. For all I know, they still do it. In secret venues that only other Ballers know about. They do a kind of fashion show where they walk and strut and are cheered on by their compatriots in fellowship and healthy competition. It's drag but also so much more. It's letting your freak flag fly,

it's a feeling of togetherness with other people you can relate to. And going home with shitty trophies, smeared make-up and the satisfaction of bringing the house down that only a night spent in "*Ta da!*" can deliver.

OK, "*Ta da!*" sucks lets go back to *duende*.

BEATS

Once upon a time, there was this small group of friends. You know the type. Everyone of this type probably is (or was—they can be annoying as shit) part of your little group of friends. The foaming-at-the-mouth would-be novelist who just wants to *experience everything*, man, but kind of burns out with the booze (Kerouac). His pal who does a bit too much speed and talks too much but it's kind of cool, you can count on him to drive all night when you need someone to drive all night (Neil Cassady). The poetic guy with issues about his sexuality, or gender, or whatever (Allan Ginsberg). The really weird creepy guy who dresses a little too formally, is into weird scientific conspiracy theories, and thinks doing heroin is really cool (Burroughs). You know all these assholes! They can be interesting to hang around with, but also a bit aggravating and dangerous. Serious criminal elements around all the intellectual shit. Bodies sort of pile up, maybe accidental, maybe not.

The group of friends had a party. Everyone at the party wrote a book about it. This particular gang was just... really good at publicizing themselves. Well connected in the literary world and publishing. Got their weird unreadable books published. Then for every work of actual art they produced, there are three books about them and their art.

This group of marketing geniuses is known as the Beats. The Beats were a movement the likes of which I honestly cannot figure out. They defined something, it's just that nobody can say exactly what. An elusive, magical something that we want to give them credit for. Something about the edges of experience, drugs, talking too much... who knows. Everyone you know has quoted you that line about the mad bad exploding people who shout "wheeee!!" or whatever the hell it is. They are everyone's excuse for being irresponsible. It's wonderful: they wrote a bunch of shitty books that I've never read and neither have you. But we know what's in them. We appreciate what they were trying to do, but can't describe it. Can you imagine the *duende* that happened at their happenings, their readings? On that bus a bunch of them drove around the U.S. in and one of the most famous journalists in the country wrote a whole bestseller about? Has anyone written a bestseller about you and your friends' cool road trip? Not yet, but you feel like it could happen. Because of the Beats. But they were some sort of miracle of seeming more fascinating than their actual work justified. Sure, you can take LSD and sit in a closet and stare at

your hand and have a magic moment, I get it. But these guys were on to something, and we still can't quantify their cool. You don't need to have your amazing group of friends get talked about as much as them. It might ruin things if you did. But they are still an amazing example of how attracted the world can be to anyone doing anything that hasn't already been done to death. (But doing things just because they haven't been done to death has also been done to death. None of this is simple.)

The Latitude Society

What happens when you *actually* try to buy cool? What does that look like? What happens when you try to just use money to make a secret society and do events and try to influence culture and beat the rest of the 'market' to something you see is going to be a micro-movement in the future? Ask Jeff Hull. He dropped $2,000,000 on the Latitude Society[†] and all he got was this lousy t-shirt. Some tech-speak thing called 'The Experience Sharing Economy.' He made a secret society without telling anyone about his six-point plan to monetize it with: Mobile Apps, Membership Services, Uses-Generated Content, Merchandise, Book Release and (get this) a Reality TV Series. And of course member fees that were hundreds of dollars a year. Clueless rich guy. It lasted about a year. It was gone in the blink of an eye once he sprung $300 a year memberships on everyone. Buh-bye.

But before it died, 15% of my friends were able to have the actual experience of being in a secret society. And they were DOWN. Everyone was totally into it. It caught on like wildfire. And because we understand how parallel evolution works, we know there are other secret societies out there. I'm not sure how this becomes a sustainable model, but what happened to this lot was Hull had like five people on salary and two spaces for like three years. He must have had it to burn because anyone who can do simple math can see that with memberships at $200 a throw it would take all the tea in China to get there. Can you say that anymore? It seems like the guy was starting to hate his audience, which is what happens when your passion becomes your job sometimes. The content they were doing was great. Basically a multi-player game that is happening in real time. Events, fables, small scale game play with some fresh ideas. I could go bananas explaining all of it, but my point here is to show you movements and by golly, this thing had legs. In about a year they collected a few thousand members who all wanted to be in on a secret. Their motto was: "SSShhhhhhhh." Pretentious? Maybe a little. Exclusive? Meh, what isn't? Was Mr. Hull trying to buy cool? Is the guy with the red convertible, over there? I drive a red convertible, am I? I bought it twenty years ago for $500...

But this lesson isn't about buying cool, it's about WHY he did that. I mean, Hull made that money devising a tool, an algorithm that averages stocks or something. He and his dad sold it to Goldman Sachs. Why not put his two million in stock

tools or something that he knows? Why dump two million in this circus act? To be important? To be cool? Legacy? No no no. He did it because he wanted to create *duende*. He saw the path. And boy, was he right. 100% right. He had the right stuff, the right team, the right idea, the right aesthetics...what went wrong?

Because it's not like the Latitude Society got co-opted, it didn't have the chance. And it's not like they sold out—which is when you go out of your way to get co-opted—although they were clearly aiming for it. I mean, when you give your movement a marketing plan that includes merch sales and reality TV shows...come on...

No, something else happened to the Latitude Society, something that has killed more movements and arts organizations than every repressive government and big corporation and church moralist put together.

They had a mitosis.

I'll map out what that means in the next chapter in agonizing detail, but for the moment, let's just say that Hull's problem was that he wanted to have it both ways. Yes, he wanted to turn a movement into a payday. But that wasn't the only problem. His real problem was that he wanted to create *and* control *duende* (and he hated his audience). That's exactly what you can't do. When you inspire people, they get to *be inspired*. Movements are collective organisms. Not top-down machines. It's right there in the name: 'Latitude *Society*.' Defined as: ordered community. He changed the *constitution* of the group by heaping on restrictions and taking away privileges and enacting taxes and work and there was a revolt!

Here's the good news about The Latitude Society: after the mitosis, a bunch of the members all created their own secret societies. The Latitude Society ended up giving birth to a few real secret societies that neither of us are cool enough to know about (and two that we are cool enough to know!) I find great comfort in that. Isn't it better to end in a brilliant shitshow than by slow attrition?

So what have we learned?

Micro-movements are generally:

- *Boutique*: The whole point of them is that they're carving out their own niche in a larger movement. Often times, that makes them:

- *Obscure (niche)*: Sure, not every micro-movement is obscure, but if it's not, then it's probably going to spawn a micro-micro-movement. And if that gets big enough that a bunch of people have heard of it, then there will be a micro-micro-micro-movement. Because if a movement inspires people, then they want to take it and make it their own. Which is

great—it's amazing. An act of creativity. That's a feature, not a bug. But it means that there are a lot of micro-movements out there, even in movements you think you know everything about, that you've never heard of. When you are in an obscure niche, you are making it up as you go...on the fail graph you eliminate the possibility of mediocrity. It's totally possible for a movement to become mediocre, that's why micro-movements are born, sometimes. Movements can totally get stale...

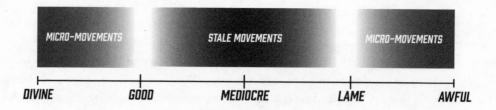

- *In Parallel Evolution*: You've probably figured out that the same movement can lead to a whole lot of micro-movements. Because they're all descended from the same source, they tend to experience parallel evolution, going through the same kinds of things at around the same times, coping with similar issues. Occasionally one will break through in ways the others won't, but it's actually pretty surprising how they tend to rise and fall and move to the suburbs together. On the other hand, they can suffer from...

- *Unique Problems*: From other micro-movements, sure, but what I really mean is from the movement they're descended from. So 'gangster rap' has problems that are unique from 'rap' which are unique from 'hip hop' (geez, I hope I got that right). Reiki healers have problems that are unique from the New Age movement as a whole. I guess the more boutique you are the more unique your problems. There's a really clever rhyming slogan in there somewhere, but, you can figure it out. I don't really do that.

- *Less competition, more opportunity*: The whole point of micro-movements is that people are inspired by a movement, want to grab a piece of it, and make it theirs, which means (if they're not posers) making it more unique. That uniqueness means more problems, yeah, but they don't do it because of the problems. They do it because of the creative opportunity. Making a micro-movement out of a movement is like homesteading, and the more unique you make it, the more it really belongs to you. (Which also means the more obscure it will probably be, but, what, you wanna be famous? Is that why you're doing this?) The more unique a micro-movement is, the less competition there is from the rest of the movement too. Believe me, nobody is competing for your idea of Donald Trump sad clown themed karaoke dinner parties. You've got that all to yourself. Unless you can make them so amazing that they inspire other people, who want to make it their own and think it would be even better if it was Ted Cruz sad clown themed karaoke dinner parties ...

- *A path to **duende***: And here we go, what's really the whole point. You get both micro-movements AND magic moments when you cultivate creativity and inspiration. So naturally, by the transitive property (Benjamin told me to say that) creating micro-movements increases the opportunities for magic moments. Which is what we want. You remember that, right?

So the fact that we are going through this tremendous expansion of movements, the fact that everybody's in a bunch of them, means that everybody's trying to create more *duende*, whether they know it or not. It's what they're looking for—and they're on the right track.

Which leads us to the biggest movement of all.

And it's movements all the way down

What started out being 'the underground' has grown so much that's it's not really underground anymore. The underground scenes all splintered into boutique scenes, all vibrant and healthy, serving their constituents and doing their things. But there are so many of them. And many of them are ground-breaking, innovative, high quality movements, no matter their size. If you can imagine all these movements as their own movement, then you will come to the same conclusion I have. It's a movement of movements. It's the biggest movement ever to happen.

Right now, everyone you know is in a movement. In San Francisco, the average person I polled is in 12 movements (let's both assume I did an actual poll. Everyone's happier that way. Just don't look for a footnote). Some of these movements are pretty boutique. Some don't consume your every moment. We have learned to 'manage' movement activity. That's amazing. Think about that for a minute. Across the globe people are not just getting by—they are learning how to organize their lives around changing the world.

Why? Well, because people want to be part of something bigger, yes, but it's more than that. Everybody's always wanted to be part of something bigger. No generation of people ever said, "We're the nothing generation. We have nothing to contribute, it's gonna be pretty dull for the next 25 years...sorry." Every batch of late teens always has to change it up somehow, either with new stuff or new combinations. Culture mines its past for ideas, for combinations and for inspiration.[5]

But with our new tech and communication tools that make talking to, potentially, millions of people in an instant for free the game is now forever changed. Investing in our kids has never made more sense. They are going to be part of movements, for sure. They are bred with communication.[6]

They have the connection thing down.

And they want to get out of the office. They're not interested in the false security of the rat race. They want a world filled with magic moments. They don't want a world that is a machine. Which means that since micro-movements increase the likelihood of magic moments, they're piling up on micro-movements. Grabbing as many as they can.

You can now make it and be totally famous (and not get a penny!) because of the domination of the DIY movement. Peak Advertising has made everyone numb to broad marketing campaigns anyway. That's the bad side, the good side is that you and two other bands can play a brand new kind of music. Let's call it Rank. There are 3 bands that play Rank. Between the 3 bands, they have a total of 450 likes on Facebook. That band can have a camp out in Mendocino on the bass player's uncle's pot farm, and 450 people can come and they have achieved Total Market Saturation. 100% success. They would be at the top of their game.

Rank is a perfect definition of a micro-movement. With a ten person research staff I could find 500,000 more, probably. In the *IS*, I showed you example after example of the poison of 'making it,' but it's prevalent in so many industries: ivory tower, politics, sales, tech, and so on...people want to be important sure, but what is all

5 Yea? Tell me punk rock didn't steal its haircuts from the munchkins in the Wizard of Oz. Go look, I'll wait...

6 Just because you can communicate to thousands of people a photograph of your dinner through your twitter account that doesn't mean you can actually communicate with people and negotiate complex parameters and diplomatic compromise!

that ego stuff? Is that a show we are seeing? Is that people just not getting it? Wanna hear a quick story about who 'gets it'? In 1980 the Clash released an album that Rolling Stone called 'the cornerstone of new music' and ranked it #1 album of the 80's: *London Calling*. Yet the radio stations wouldn't play the 'hit' off the record, *Train in Vain*. The Clash put it as the last song on side B and didn't write it on the liner notes. Mystery song. The band thought it was funny. It totally broke the entire system. So Duran Duran got all the airplay, the Clash got to stay cool and 5 million copies is nothing to sneeze at. But *Train in Vain*, arguably the best punk rock song ever, got zero airplay not just because the DJ's couldn't see the name of the song on the album, but because they couldn't see how long it was! And they budget their time for the commercials. The song was put on the record with no labeling as a secret gift to the people who love the music, and to KEEP IT OFF THE RADIO. Their intention was to do something outside the mechanized system of money generation.

The Clash broke the machine. Rank would have too (if it actually existed). It's kinda what micro-movements do. They are trying to create magic. Which means—stay with me here—that since that magic is the only way to change the world, and micro-movements create the conditions for it to visit us, it matters that those micro-movements don't crash and burn like The Latitude Society, or get co-opted like Vogueing. Which means we want more people to be better at cultivating the conditions under which micro-movements thrive, so as to interface with the world as a sentient system rather than a machine. Which means people have to learn how to avoid things like mitosis and burn-out.

Which means I should probably explain what all that is, and why it's so deadly.

Being part of a movement is easy. Anyone can be. But if you want to gain equity, you have to do more than consume the movement. You have to show up. You have to be in or start an art group.

Art Groups

2000 years ago, when the Jesus thing was getting really big, really picking up steam, turning into a movement that would eventually take over the world, there was a theologian named Tertullian. Total weirdo. Kind of a hard core, he was to Roman society what early punks were to ours. Only in reverse, because he was a Christian monk. Or something. I dunno. This was a time when *not* going to the orgy was a shocking act of social rebellion. It's complicated. *Wholesome is the new decadence* kinda thing. Anyway, at one point Tertullian got really sick of all the philosophers trying to horn in on Christianity and convince everybody that it wasn't such a radical act. They would show him with logic and reason that what he believed couldn't possibly be true. The philosophers were a lot like those teachers everybody had back when I grew up, who would tell you, "You know, Rock and Roll isn't really so different from Lawrence Welk! It's just a smaller big band, and I bet you'd just love Frank Sinatra if you gave him a chance!" They didn't understand rebellion. They would never be able to understand why the 120 grit sandpaper the Feederz[7] put on their album cover was so cool. Those teachers didn't have the tools to see that not being able to tune your guitar was a kind of freedom. All this was beyond their logic, beyond the mechanistic system that they were too lazy or too stupid to get out of.

Back to Tertullian, he put his foot down and said something that so stuck in people's craws that they remember it today. He said, "What has Athens to do with Jerusalem? Or the Academy with the Church? I believe *because* it is absurd!"

Which was a total fuck-you to philosophers. No matter what you say about my faith, no matter how you intellectualize it or philosophize about it, or get all your smart friends to recontextualize or problematize it or whatever you people do, I'm just going to keep on doing my thing. You have no power over me. You think my beliefs are absurd? Tertullian's reaction was, "Fuck you philosophers! *I believe **because** it is absurd!* Faith has nothing to do with philosophy! You're not my real dad!"

We have a similar 'fuck you' attitude today in our art groups. When I say to an art group, and I've said this a lot, that every successful art group eventually turns into a real estate scam, people's immediate reaction is, "Fuck you, Chicken! Not my art group! Art has nothing to do with real estate! You're not my real dad!"

7 The Feederz put the sandpaper on the outside of their album cover. Every time you took their record out from your record shelf, you would remove some of the album jackets next to it. Eventually you would have 'sanded' away all the other records, until only the Feederz record remained!!

Yeah, well, sorry. Just because Tertullian was a hard-ass sacred punk doesn't mean he wasn't full of shit, "I believe *BECAUSE* it is absurd?" Okay, that's a magnificent 'fuck you' to authority, but when people start saying shit like that you know it's time to bail. You won't like what comes next: fanatics are always telling you to sell all your stuff and kill yourself because the comet is coming and we have to hitch a ride out of here with the lizards from another dimension.

Trust me, I've almost given that speech. And come on, is that how you want to live your life, anyway?

What I'm saying is: the hard core denial that art could have anything to do with real estate is one of the big reasons every successful art group eventually turns into a real estate scam. Everybody's so busy denying it that nobody sees it coming.

What makes dogs dig?

I certainly don't know what makes a dog dig, but if you have ever watched the joy of a dog going full bore at the beach with reckless abandon you have seen pure fulfillment and purpose. They just know how to do it. And when someone calls you and says, "Hey, let's build a catapult and charge artists $50 to get their work in the MOMA!" or "I just scored a lease for 3 months on Rodeo Drive, let's open a fecal facial shop and smear shit on the rich and famous!", the reaction is similar to that digging dog. You know just what to do. You say, "I'm in." You see the pieces on the board and you can line them up to get a clear shot at that magic that's at the end of the idea.

Bam! You're in an art group. ('Art group' defined broadly.)

You are doing something that has happened a million different ways a billion different times. Get in the van. Inspiration to contribute. Show up. That kind of thing. You've got an idea that you are going to implement in fellowship with like-minded idiots. You know what that looks and feels like. But if you get good enough at it, invariably the destination is the same and it's brutal: it all becomes a real estate/ investment scam. I know. I know! Unless, of course, you know that the system is calibrated that way and you try to avoid it.

What is Real Estate?

Usually real estate has a very specific definition: land and buildings. And sure, that's some of what I'm talking about. But it's not all I'm talking about. I'm also talking about digital real estate, like a website address; or PR real estate in an 'attention economy' where everybody is competing for name recognition; or a

following of loyal subscribers. Real estate for the purpose of this shenanigan is any potentially transferable asset up to and including the moral authority that comes from being the officially recognized holder of a legacy. Like, if you're the Metropolitan Opera, you get to talk about the whole history of opera stuff your esteemed company put on, even if you fired all the guys who actually did it and hired a new CEO who did the network programming for VHI. You're still the legacy holder, you've still got the name, and the donors list—and all of those are just as much real estate as the actual real estate the Met holds in New York, which must be worth a fortune. Or two. Or three fortunes. Probably four. Don't get me wrong, usually 'real estate' does end up being tied to land in some way, but in the world of art a title or a mailing list can be real estate too.

Are you seeing where this is going? No? That's so cute...

Content providers

People doing art[8], whatever it is, are making content. And that content starts to accrue value. Somehow. We think of art as something that has nothing to do with money ("YOU'RE NOT MY REAL DAD!") especially in SF, but whether or not it's 'money,' if people do art of any kind for long enough, with any kind of success at all, value starts to accrue around it. It just does. Amazing things start to be built. Outsider art becomes mainstream in less than five years, every time. And that's where things can go wrong, because the artists were never prepared for success and suddenly there's a fight over the real estate that the art group was never supposed to be about.

And 99% of organizations will follow the exact same patterned life cycle, from birth to real estate/investment scam, that I will share with you now.

The life cycle of art groups:

1. Arts organization forms based on a spark/idea that will lead to *duende*, no constitution or agreement or thesis, just doing it for fun

2. Project takes 50 times more energy/money/ space than anyone thought

3. Something works/clicks, path to attention/ revenue stream discovered

4. Manifesto/vision statement is written/spoken in some form, Control is introduced for the first time

8 art by definition here is anything that is pointless and intentional

5. Mission/Vision questioned by members, many people thought mission/vision was different than what current leadership is proposing

6. Capital arrives and needs to be managed: social capital, money, whatever...people fight over it

7. Mitosis: struggle for dominance/control, groups splits, becomes two groups struggling to eliminate the other and control attention/revenue stream

8. One side wins, circles wagon, goes dark, re-brands, shuts other side out

9. Severe burn-out in defeated members, possible sabotage, winning-side output diminished because defeated members were the creative part

10. Newly-minted organization has better reach and revenue but lacking magic of original collaboration, loses ability to create new content, trades on old ideas to get grants/attention/new members

11. After time, leadership has deathgrip on organization, Founders Syndrome sets in, organization distrustful of energetic young members, innovation evaporates, revenue stream increases, management refuses to step down/retire, would rather see organization fold than let others help

12. Arts organization turns into real estate/investment scam

There it is. Every arts organization you've ever seen has either gone through that, failed before they could go through that, or is in the process of going through it this very moment.

Here are some examples of art groups that demonstrate the point. I'll introduce you to them here simply, then later we see what happened to them and draw some correlations.

KUSF

KUSF was a radio station from 1963 to 2011 that was broadcast from University of San Francisco but is now an internet station called SF Community Radio.

Krumpin'

Krump is a dance movement from the streets of LA. The dancing is kinda like hip hop or break dancing, but more street. The dancers wear odd, outlandish clown makeup.

Craigslist

Craigslist is the first startup. An SF-based non-profit community platform on the web that is a resource for jobs, housing and classified ads. Now on 87 planets!

National Geographic

Nat-Geo is a media giant conglomerate that deals with natural history documentation in print and television. One of the oldest companies on Earth: originally a fraternal organization of mapmakers.

Academy of Art

Founded in 1929 as the Academy of Advertising Art, the Academy of Art in San Francisco is a privately owned, for-profit university that is also one of the largest property owners in San Francisco. If you don't see where this is going already, you should go see an eye doctor. An eye doctor who has massive real estate holdings and used to be an 'eye advertising doctor.' He'll set you straight.

Swimming Cities of the Switchback Sea/Serenissima

The Swimming Cities was the name of the boat project that did four major trips using salvaged and re-purposed materials to make iconic, beautiful junkboats with shows.

Burning Man

Burning Man is an annual art event in the Nevada desert that attracts a record 80,000 participants who construct a temporary city with no commerce.

Cell space

C.E.L.L. (Collectively Explored Learning Labs) was a 5,000 square foot privately held non-profit community center in SF's Mission district from 1996 to 2014.

Rev Billy

Rev. Billy (Bill Talen) is an actor and activist from NYC who, as a southern Baptist Reverend, exorcises the evil from people held in the grips of the demon of consumer culture.

Maximum Rock And Roll

MRR is a SF based newsprint magazine started by Tim Yohannan in the late 70's that was (and is!) a resource guide for punk and hardcore music and culture.

REI

Recreational Equipment Inc. is a member driven non-profit outdoor equipment company with democratic board, and is a consistently award-winning place to work.

So, I've given a brief description of these eleven groups and why they are nifty. Different organizing structures, different content, but all generally based in or around the arts defined broadly. And nine of them followed the script in some way that I shared with you on page 45.

Putting the pieces together

Now, in those arts groups, how did things fall apart? How did they become real estate scams? Let's take a closer look:

Don't turn that dial!

53 years ago, the University of San Francisco got an FCC license to broadcast on an AM signal and KUSF was born. They did six hours of programming a day from a tiny basement on the campus. Eventually, they upgraded to a pretty healthy signal (2,500 watts) on the FM dial and by 1981 they were 24/7. Community programming, educational programs (some in Polish?) and a general amateur embrace of all things. College radio is an exceptionally powerful medium that I hold in very high regard. Commercial-free, free form radio is a perfect example of a collaborative artwork and is at the very ore of the human condition. Or something. The point is KUSF was a beautiful thing with a long reach and an established audience that belonged to the people who made it so weird and wonderful.

Until one day, it wasn't.

"The door was stuck or something," the DJ told me over the phone. "Then I realized my key just didn't work anymore. They changed the locks." The 2008 financial crisis made making ends meet really hard for USF, and a non-profit classical station offered them three million bucks for their spot on the dial. They took it, and locked all the DJs and the producers and the programmers out.

Those people, the people who were actually making the art and providing the information and connecting with the public and doing the works—they had no idea that it could all be taken away from them just like that. They never really paid attention to the fact that the radio station existed at the pleasure of the board of the college. Until the locks got changed, it never occurred to anyone to ask: "Hey, do we have a contract or something?" Well they didn't. They had, basically, nothing. People poured years and years of their lives into KUSF with ZERO equity. The University didn't even have the decency to give them a week's notice so they could have their last shows or try to direct the listeners to their internet stations. I hear it was a battle to even get their stuff from the offices.

USF is an institution steeped in 'values.' It's a Catholic university, so they've got the whole 'Do what God thinks is right' thing going. If you ask, they'll tell you that's important. It's a non-profit university, so they're supposed to be dedicated to the public good. Oh, and it's a university, so they're supposed to provide educational opportunities and value learning.

And none of that, absolutely none of it, made a difference: they turned the radio station they had nurtured for over 50 years into a real estate scam, selling it out from under all the people who had been doing the work and telling them they have no equity . What was the real estate? Not the building, in this case, but the place on the dial: 90.3FM. When times got hard, none of the university's 'values' counted. So now when you tune your radio to those numbers on the dial, you're listening to a pre-recorded playlist of classical schlock. From Los Angeles.

Krumpin'

Emerging in the early 1990's, clowning was a mostly solo dance style that was a hybrid of hip-hop and break dancing, just with not so much of the ground work. The dancers would wear clown makeup and sometimes clown outfits, such as loud over-sized pants, along with other hip-hop fashion. Chronicled in the 2005 film *Rize*, Clowning had a mitosis moment when a handful of the most talented dancers in the crew wanted to push the art form to a more aggressive, darker place closer to the Brazilian martial art Capoeira (or even flamenco, maybe). So they split, and started a 'completely different thing.' A hip-hop dance company that wears clown makeup. And Krump was born. The split of Clowning/Krumping followed the 12 steps perfectly. The movie is made around the big dance showdown called the *Battlezone*, where it's Krumper vs. Clowner with 4,000 people in the audience and non-stop drama with the dancers.

Krump has its own phrases and lingo, and the whole architecture of it is really beautiful and quite sentient. The way it works is usually two people battle each other in a circle of others dancing in a subdued way. One dancer busts out his/her moves while the other one watches and can engage or make gestures and other stuff, but it's the other person's 'turn.' The dancer's crew can also help throw down. They have a term for when, in the madness of the dance, you lose yourself to the art. It's called 'gettin' buck.' They have named the transcendence that can be achieved with their bodies responding to all the eyes on them and being lost in the moment of beauty. 'Gettin' *duende*' just didn't roll off the tongue.

Craigslist

Craig Newmark has gotten tens of millions of people laid. Think about that for a second. www.craigslist.org changed the world. One out of five households in the world has internet now[†] and some substantial percentage of that is because of Craigslist.org. It's changed economies. It's made people fabulously wealthy. It's undercut some industries and they went bye bye. It made the world more accessible. It is a piece of software/technology that made the world better. It solved problems, made consumers more effective and savvy—all the while contributing to community building in a hands-on and fair/equitable way. Right on, Craig.

There was a time, though, when you could *also* visit www.craigslist.net. It looked the same. Had the same font and colors. Just .net instead of .org. It didn't last long. Craig had a partner. They had a split. So for a hot minute, there were, in fact TWO craigslists. How could the other guy think he was going to get away with that I don't know. But it makes for a perfect example here that every organization sort of follows the same patterns. From innovative community websites to hippy communes to Burning Man camps to religious groups, musical/theatre/sketch comedy troupes, neighborhood associations, steering committees, car clubs and on and on and on. So many of them read from this script. No one is immune. Not even our own anointed St. Craig.

Leave it to the professionals

My ex was a production assistant on a film for *National Geographic* about bugs. Let's call her 'Anna.' She did what a PA does... go get coffee, load some gear, get people to sign release forms. The director was a great director. A Brit, as I remember. The scenes were of how we actually live in a bug's world, not the other way around. Amusing. Terrifying. Educational. And exceptionally well-done. As a production assistant Anna traveled around and helped the professional crew get the shots. She had never actually directed anything, but thought that maybe someday that's what she would want to do. Like most PA's.

They got all the shots they needed except one. It was something bug-related that only happens at a specific time at a specific place, and the directors' visa had expired and he had to go back home and no amount of explaining 'The bugs haven't hatched yet!' helped. So he got his crew together to go film it even though he wasn't going to be there. It was a simple shot, it didn't really need a director. I mean, you're filming fucking bugs, what? But Anna is nothing if she isn't a pushy opportunist. "If I go to this shoot, would I be directing?" she asks. "Sure," the director says. "Whatever you want." With that in hand, she begs him for director credit when the film is made. He gives her a co-director credit under his name. The film gets nominated for an Emmy.

Now, he doesn't think the film is going to win and decides that it's not worth the trip to the States. Tells Anna that if she wants, she can go. Gives her his credentials. Mind you, she 'directed' a scene that lasted 30 seconds with a pro crew doing all the work. She never made a budget, doesn't own any equipment and has never edited anything in her life. The film was incredible. A fantastic journey into the darkest concept I'd ever heard: that we are slaves to bugs. Crazy. Irreverent. And very funny. That special kind of British funny that we Americans are helpless to respond to with anything but surrender. The competition for the Natural History Documentary Category sucked that year. *Bugworld*[†] won the Emmy.

In this case, the 'real estate' that we are talking about is Anna's title: Director. I think you get a chair that says so and a parking spot right out front. And an Emmy. The director's credit, and the Emmy, is a scam. And it made her career. That title, and the Emmy—far more than any money the film ever made—was the real estate. Anna's power play was the scam.

Now, I'm not a hater. Maybe she didn't mind collecting that award for someone else's work. Maybe she doesn't see it as a 'scam.' I mean, it's a victimless crime, no?

Tell that to the person who hired Anna the Emmy-Award-winning and totally *unqualified* Director for her next gig. *Fake it til ya make it!*

So what's the lesson here? I'm trying to show you a system, a pattern that keeps happening. Over and over, it's the same story of manipulation and deceit and Control.

Academy of Art

When I say that the Academy of Art in San Francisco is a for-profit university, that should really tell you everything you need to know. Nearly every for-profit university in the United States is a scam already, pulling students who are desperate for a degree in with false promises and lots of help getting student loans that—get this—are paid to the university by the government even if the student defaults and goes bankrupt because their crummy education gave them a worthless degree that employers laugh at because it looks like a funny cartoon they once saw in *The New Yorker*. Only it's simultaneously both more tragic and more humorous. More tragic because thousands of people's lives are ruined by these vultures every year, and more humorous because *The New Yorker* just isn't funny anymore.

The Academy of Art is definitely like that. But don't take my word for it, this is what a 2015 expose in <u>Forbes Magazine</u>[†] had to say about them:

But behind the shiny façade is a less than lustrous business: luring starry-eyed art students into taking on massive amounts of debt based on the 'revolutionary principle' (Stephens' phrase) that anyone can make a career as a professional artist. No observable talent is required to gain admission to AAU. The school will accept anyone who has a high school diploma and is willing to pay the $22,000 annual tuition (excluding room and board), no art portfolio required. It would be easy to accuse AAU of being a diploma mill, except the school doesn't manufacture many diplomas. Just 32% of full-time students graduate in six years, versus 59% for colleges nationally, and that rate drops to 6% for online-only students and 3% for part-time students.

Should I go on? I don't need to, but, this really is kind of an amazing scam—even for a for-profit college—so let me tell you about it.

The Academy of Art started out as kind of legitimate, at least it looks that way to me in hindsight. I wasn't there. During the Great Depression, Richard S. Stephens was a legitimate painter and magazine art director who got a two-room loft in San Francisco to teach people how to get jobs doing the art for magazine ads. Sure it was a hustle, but so what? It was pretty straightforward, and it did pretty well for itself.

But his kids and his grandkids, they saw the writing on the wall when rents started to rise in San Francisco, and so they started buying buildings. How many buildings? Well, today the Academy of Art is one of the largest landowners in San Francisco, holding on to at least 40 buildings—some in primo spots—31 of which have got planning code violations going back decades. (Again, this isn't me telling you this, it's Forbes!)

What do those planning code violations mean? They mean that the Academy of Art buys buildings in a city where every square inch is needed for housing and civic use, and illegally converts them into campus buildings. They've changed office buildings into classrooms, a church into an auditorium, and…this is the big one…apartments into dorms. They've illegally taken housing away from teachers and janitors and nurses in order to put up more of their students, which allows them to grow, which allows them to buy more buildings.[9]

Do you see it? They are a literal real estate scam. Buy up buildings, kick the tenants out, convert them into dorms, bilk the students for all they're worth, use that money to buy more buildings, kick the tenants out, convert them into dorms…

It's criminal. Literally criminal. How do they get away with it? Big political connections. Somehow the Planning Commission took years to figure out what was going on, and then more years to levy fines, and then the fines weren't getting paid…

9 and more cars for their world renown collection of vintage automobiles.

And it's all powered by kids who just want to learn to draw. Or make videos. Who come there with the best of intentions, for the best of reasons…they want to get more art in the world…and it never occurs to them that they're walking into a deep, dark hole, because what has Art to do with Real Estate?

We've gotta stop thinking that way. We have to. For the kids.

Swimming cities rivers of blood?

"Can you make them go?" Of course I can make them go. So I did. The artist known as Swoon wanted to make a junkboat and go down the Mississippi. So we did. She made a model and we built it and I can write 20 books on that. That little redhead was our general. We were foot soldiers in her war. It was her vision, we were her hands. That can work really well.

"How about the Hudson river this time?" Aye Aye, we did the Hudson two years later. I can write another 20 books on that trip. Swoon was the general, I was the chief engineer. Seven boats.

"Is it true you've never been to Europe?" Break three boats down, put them in shipping containers and drop them in Slovenia. Built out of 100% all-American trash. Traverse the Adriatic with bullshit and crash the Venice Biennale. I'd follow that little redhead anywhere.

But what happens when the little redhead's crew decides they want to do their own boat project. Well, a few of them. Different project. Is it cool for them to use the Swimming Cities name, for fundraising? Is that cheating? Is that OK? I mean, you gotta let it happen or you're a hater, right? Well it didn't exactly follow my twelve-step script, but that real estate part sure is familiar. And I wasn't there to know anything, but those guys had fucking *balls* to do junkboats down the Ganges. I put this here as an example in the "didn't see that coming, did ya" category.

Burning Man

The fact is in 1996, Burning Man had a mitosis. Forever after, the organization and culture was cleaved in two. Our side had a name: Friends of Smiley.

In 1996 on the Friday night of the burn week, at 3:00 AM, a button was pushed sending voltage to a neon smiley face that some of the organizers put in the head of the burning man. It was a momentary button, like a doorbell. They pushed the button for five seconds. And it started a war that rages on to this day.

"Bring it down!" Larry[10] shouted, demanding they lower the burning man to the ground so he could stomp on the neon, the glass tubes shattering under the heel of his loafers. *Somebody* doesn't have a sense of humor. I mean, really. For a while, BM was indeed two organizations. The one that the Friends of Smiley thought they banished to oblivion by their absence when they quit, and the one Larry was diligently planning like a Machiavellian super villain. Every one of the steps up to and including #8 was played perfectly up to that point. They went through every one of the twelve steps like they were reading a script. It's like I wrote this book to make this point.

So many people from that early time invested so much of themselves. So much was asked. So much. It was always more. In 1995, they put out a newsletter that said in bold, thick letters at the top *"You Are A Founder"*. "We waited. We watched. It was agonizing. They took. So. Long. Watching and waiting for them to learn how to lead was a lesson in patience. Don't get me wrong, it wasn't all terrible. The *duende* was very strong there. Everyone loved the magic, but we had zero equity. Founders' Syndrome was apparent almost immediately. They have big plans for the $6.5 million piece of property they bought in 2016: Fly Ranch. Now, I toss the word 'scam' around, but you have to understand that to a carny like me, scam may have a completely different meaning. There are worse things for the Burning Man organization to do with their money then control an iconic, unique property like a hot spring. But c'mon, you can't expect me to see the same thing happen over and over again like this and not write a book about it.

CELL Space

"How the hell are we going to come up with $5,000 *every month*?" Isn't that precious? We would KILL right now to pay one-sixth of current market value. CELL space went through the twelve steps back and forth so many times I lost count. The power struggles were just crazy. One group would lose power and another one would rise up. At one point, the board had forty people on it. At another point, only two people had keys and NO ONE was paying rent. In a consensus organization, the wrong person got the power every time. It was totally crazy. There was a missing element there that I could never put my finger on, but now it's so obvious. There was no mentorship there. Had some great, magic times there though…

I'll admit that CELL would have been the perfect place to claim as sovereign space and all that jazz. The first group would have loved that. They were desperate for the confluence of art and activism and had the right amount of hippy to ask about "your

10 Larry Harvey is the guy who brought the burning man statue to a Cacophony Society formal cocktail party on the playa in 1990 that eventually became the Burning Man arts festival, I think. It's really hard to say at this point because I've met no less than 2,500 people who claim to have been at the first Burning Man. I've seen the photos, it was more like seventy-five people.

heart" and crap like that. I can see them now, all sitting in a big circle stretching and arguing the details of their document. That's a nice thought.

Rev. Billy

Billy was walking like a zombie in Washington Square Park with his friend Spalding Grey. He was just defeated. Spalding told him to snap out of it, to stop feeling sorry for himself. He told Billy, "You don't want to be a producer anyway." He said, "You are having a status panic."

"Go to Times Square and preach and preach and preach. Preach until you drop," Spalding said, "Find that thing, that rhythm. Get back to your preacher..."

When Spalding Grey gives you performance advice, it's a good idea to just take it. That's a man who knew what he was talking about when it comes to show. The rest is Stop Shopping history. Rev. Billy and his Church of Stop Stopping is the stuff of legends.[11] He and his partner Savitri D. are a powerful couple. Effective. Prolific. Their message is simple: there are consequences attached to commerce that are *not* acceptable!!! But many years ago, Billy Talen lived in San Francisco and ran a theatre and had a completely different life as an arts facilitator. I wonder what happened?

In the 90's, Billy Talen ran Life on the Water, a 250-seat, non-profit theatre in Fort Mason Center. The theatre was owned by Billy and three other people, and controlled by a non-profit board. He worked 80 hours a week producing the Solo Mio festival and other work by theatre and dance troupes. He traveled to other cities to check out work. It was 'his baby.' He worked hard to get some grants. The Solo Mio festival was a hit. Everything was going good. He worked hard, loved the work and never saw it coming.

Bill and one other owner were a couple. They broke up. The ex and the other two partners asked their board to fire Bill. By this time the theatre was getting hundreds of thousands of dollars in grants. "After seven years, I had no equity. Nothing. Like, just zero consideration for the effort. No protection." Blindsided. Effective immediately: Bill was fired and there was nothing he could do. This example is different than the others in a lot of ways, but they went through all the steps. They just stopped at #10. The theatre closed about two years after Bill left.

I think Billy makes a better New Yorker than a Californian. I just can't imagine him driving, it's just terrifying. I have every confidence that guys like Billy will ALWAYS be OK. He's a survivor. I'm glad that there is a Rev. Billy in the world and happy to have the example here that Billy is the embodiment of Severe Comedy. You think he's just an actor in a facacta suit? Well, you're right about the suit. But you're wrong

11 I was sainted by his church for keeping that auto parts store out of Dolores Park

about him acting. Very wrong. It's not just shtick. He's a great public speaker, sure. He's got the technique and the experience. Lots of it. But he also comes with an enthusiasm and a gentleness that you only find in people who dedicate their lives to service. Which he has. He has given his life to being a cleric of the free thinkers. He channels divine grace though *duende*, and the activism he does is all play and fun and hysterical.

THE THREE THINGS AND THE THREE OTHER THINGS

IT HAS HAPPENED THAT IN THE PAST I HAVE MADE ERRORS SO EGREGIOUS THAT I HAVE SAT MYSELF DOWN AND RE-TRACED THE STEPS TO SEE WHAT THE PROBLEM WAS AT ITS CORE. THROUGH THIS REFLECTION I HAVE COME UP WITH 'THE THREE THINGS AND THE OTHER THREE THINGS.' THE THREE THINGS ARE A WAY OF SOLVING PROBLEMS. IT'S VERY SIMPLE, ELEGANT AND EASY TO USE. SO SIMPLE, IN FACT, THAT YOU MAY BE INSULTED THAT I EVEN WROTE IT DOWN HERE. BUT YOU WILL FIND THAT IT'S HARD TO USE FOR SOLVING PROBLEMS THAT YOU ARE NOT HAVING WITH A MACHINE. YOU SEE, AS A MECHANIC I WAS TRAINED WITH THE FOLLOWING MANTRA: ONLY CHANGE ONE VARIABLE AT A TIME. BY PROCESS OF ELIMINATION, YOU WILL:

1) IDENTIFY THE PROBLEM. ONCE YOU HAVE IDENTIFIED THE PROBLEM, IT'S USUALLY PRETTY EASY TO 2) IDENTIFY THE SOLUTION. THEN ALL YOU HAVE TO DO IS 3) IMPLEMENT THE SOLUTION. WORKS GREAT WITH MACHINES TERRIBLE WITH PEOPLE PROBLEMS.

AUTO PARTS DON'T GET ATTACHED TO EACH OTHER. THEY DON'T CRY WHEN YOU REPLACE SOME OF THEM. A MACHINE DOESN'T HAVE CREEPY BROTHER-IN-LAW OR ROOMMATES WHO ARE LIGHT SLEEPERS. THEY ALSO DON'T HAVE ANY ENTHUSIASM, YET. A MACHINE CAN'T HAVE TECHNIQUE OR EXPERIENCE. THESE THREE OTHER THINGS ARE IMPORTANT THINGS TO ACHIEVE BALANCE IN WHICH A MACHINE HAS DONE PERFECTLY BY SCORING 0.0: JUST LIKE BLUTO'S GRADE POINT AVERAGE.

ENTHUSIASM
TECHNIQUE
EXPERIENCE

THE OTHER THREE THINGS ARE THE QUALITIES WE WANT IN A LOVER, AN AIRPLANE PILOT, A FRIEND, A THERAPIST, ETC...EXPERIENCE, TECHNIQUE AND ENTHUSIASM. BUT WE WANT THEM TO BE POSSESSED IN IDENTICAL, EQUAL AMOUNTS. WHO WANTS A BRAIN SURGEON WITH MORE ENTHUSIASM THAN EXPERIENCE? NO ONE. HOW ABOUT A GUY THAT HAS SO MUCH EXPERIENCE THAT HIS ENTHUSIASM IS DWARFED BY IT? TECHNIQUE IS GREAT BUT YOU NEED EXPERIENCE TO KNOW WHAT TECHNIQUE TO USE, WHICH IS USING EXPERIENCE, AND YOU HAVE TO HAVE ENOUGH ENTHUSIASM TO MAKE IT THROUGH THE EXPERIMENTATION.

IT TAKES A MECHANIC TO SEE HIDDEN SYSTEMS IN THINGS. IT'S JUST A PROCESS, IT'S NOT LIKE SOME GENIUS OR SOMETHING. IT'S VERY STRAIGHTFORWARD. TO A MECHANIC EVERYTHING IS A SYSTEM: NOTE VARIABLES. NOTE CONSTANTS. ISOLATE. TEST. CHANGE VARIABLE. TEST AGAIN. ELIMINATE OPTIONS. REPEAT METHODICALLY. AT THE END OF THIS PROCESS, YOU END UP WITH ONE AND ONLY ONE OPTION. THIS IS HOW TO IDENTIFY A PROBLEM. NEXT YOU DECIDE IF YOU ARE GOING TO REPAIR, REPLACE OR RE-DESIGN. THAT IS YOU IDENTIFYING A SOLUTION. THE NEXT STEP IS TO OBTAIN THE RESOURCES NECESSARY TO IMPLEMENT THE SOLUTION YOU HAVE SELECTED. SO. IF THIS IS HOW YOUR MIND WORKS, DO YOU HAVE ANY IDEA HOW FUCKING UNLIKELY IT IS THAT YOU WOULD END UP DEVOTING YOUR LIFE TO PURSUING *DUENDE*? HOW DID THAT HAPPEN TO ME? HOW DID I GET THAT LUCKY?

Two examples here of organizations who have done great work:

MRR

Starting off as a radio show in the late 1970's, Maximum Rock and Roll (named after The Who's *Maximum Rhythm and Blues*) is an organization that has defied the twelve steps of art groups exploding by sticking to their narrow focus and keeping their model 100% outside of any commerce. A niche punk rock magazine now on its 400th issue, they have never once deviated from their prime directive. They have never had a mitosis or anything like that. In the early 90's, they were *bombarded* with new material for review and other attentions, as punk 'broke' and bands like Lynxx changed their name to Subgenerates when they didn't get the pink metal record deal they saw on MTV. This caused the organization to narrow its focus even more, which they were criticized for (by me, even!) But they had the longer view.

I include them here for two reasons: the first reason is so there is an example of where I gain my hopefulness from. The other is for you to see what it takes to not have things melt down and how that is possible with a constitution that was never written down and that has lasted 40+ years. 18 of them past the founder's death.

REI

What began as a group of 23 mountain climbing buddies is now the nation's largest consumer cooperative. With six million members and revenues around $2.2 billion, REI is a great model for my second example of people who are doing it right. The question is: is the model scaling?

With so many members not participating with the many unique features of the co-operative, REI's member model is seen by critics as nothing more a discount card. Less than 1% of its members participated in the last ballot that was mailed to them. But their governing structure is quite strict: there is no path to board membership without the approval of the Board Nomination and Governance Committee. Ostensibly, REI is owned by its membership and the board serves at the members' pleasure. All profits are distributed at the end of the year between all members. Usually about $25.

This is a company that is on like every "best company to work for" list. They offer their employees two paid days a year to just go outside and play. Part-timers get health insurance. They offer their stores after hours to local non-profits for meeting space. They are closed on Black Friday. What's it gonna take before you love this place? What? You? You're a member? You love them already? Great!

Why didn't you vote in the election for the board? They sent out six million ballots. Why aren't we eating that shit up? Well. I'll tell you. It's because when faced with authenticity of REI's fun election, we see junk mail. It looks like one of the other seven million pieces of junk mail that are jammed through your mail slot. It's because they aren't jumping up and down about. They aren't hiring famous actors to make commercials on TV to push the big election. It's not their style. Maybe they're like me, and see now as a time to experiment and that the time to push these ideas is coming, but they're not quite here.

Patterns and People

We think organizations work like machines. They don't.

It's easy to see the patterns in machines from a distance, because they're designed around those patterns: you don't even really have to look at the machine, just a blueprint. If the machine doesn't work the way the blueprint says it will, then either the blueprint's wrong or the machine is broken.

But personal behavior and relationship systems, people working together, function much more like organisms. Two organizations can have the exact same organization flow charts and policies, and those charts and policies can be completely accurate, but the organizations can still behave very differently based on the personalities of the people involved and the way they interact.

Yet I noticed that somehow every collaborative artwork I've done went through the same exact car wash. It was uncanny. The last few times I knew it was going to happen and couldn't stop it. Which sucked and was fascinating/horrifying. Trying to save arts organizations from themselves has been the worst horror movie of my life. It's like a seven car pile-up on the highway with a serial killer in every trunk.

The reason the same thing keeps happening, no matter how different and distinct the organizations are, is because they all share a common delusion: that the artists and doers *automatically* have equity. Specifically: assumed equity. Especially in leaderless collectives that have embraced a collaborative model.

Again and again people think they have equity, and they have none. They think that because they put in time or money or it's their idea that they have ownership. Because that's the way the world works, right? Everything is fair and anyway I have the emails to prove it and besides they are my friends they would never do that. Right? Time and time again when any shred of success comes, people assume things. They *believe* things instead of *knowing* them. And the fact is that no one is prepared for success. Not really. No one planned for it. No one can handle it. People aren't used

to *actually* communicating, so they assume that everyone is thinking the same thing they are. It's both a kind of laziness and a kind of sabotage. Any of these Archetypes ring a bell?

Archetypes in failing art groups

- The people who will do anything to avoid whatever conflict is happening now.

- The people who quietly walk away.

- The new people who have no idea that epic drama ended three seconds before they walked in the door.

- The guy who does all the work and is happy to.

- The guy who does a little work and never lets you forget it.

- The guy who put a bunch of money in four years ago but didn't keep records, now any money that comes is his forever.

- The guy who takes the money from the door of the event and never answers any direct questions on where the money went ever and people just want to drop it because they don't want to deal with conflict.

- The guy who fucks every girl that walks through the door.

- The two who fight for control.

- Vision people who are into the idea and otherwise useless.

- Complaining guy, always talking about how generous and self-sacrificing he is.

- Those only there for the hoody, the emblem of participation

- Differentiators, us vs. them, who draw a line behind them. No more room!

- Chroniclers, storytellers.

- List makers.

- Den mothers.

- Wife of the guy with the talent who is looking to pick a fight.

Yep, they can be in every single organization that doesn't give equity. With the shared illusion of equity, plus the same characters recurring again and again, an inevitable pattern forms that I am sharing here.

Just reading this should prevent you from having to live it. Because who wants to make Chicken John right? The archetypes exist in all of us, and they come out when the group goes through the car wash.

Putting it all together...again

Okay, so, let's review. Take a big picture look at what we're talking about. Then we can all take a break and have champagne and pizza. Or toast some marshmallows. Or wrestle in a cage match. I don't want to tell you how to spend your time.

Society made immense progress across the centuries by creating mechanistic systems—including literal machines. Who were these people who created all the pumps and bearings and gear meshes that power the world? I don't know. But holy fuck did they make textiles cheap and food plentiful and consumer goods so EASY to consume. We instituted public schools and 9-to-5 office jobs, and it's all gotten us a land of plenty where we literally could give everyone a good life if we just put our minds to it.

But we don't, because that's not the logic of the machines. That's not what mechanistic systems do. They restrict, hoard and monetize everything. It's *Control*. The Twelve Steps To Art Groups Exploding is also the power of *Control*.

I call that: The Un.

So we're looking for another way, we're looking at the world as an organism, not a machine, and it turns out that social organisms are powered by resources and *Chaos*. Community, fun and forgivness. Tolerance lives here.

I call that: The Is.

And we create inspiration and magic moments through art, movements, and micro-movements. Which is why we're in the middle of a Movement of Movements. People are looking for magic moments to help them change the world. And they're finding them. And they're trying to build on them...

...and then they're crashing and burning, because their arts organizations, clubs, collaborations and associations, the most effective tools they have to really create

those magic moments of connection and effect transformational change, don't have the support they need and explode because of problems.

And so, what could be a glorious social transformation—ushering in a new time of global understanding and innovation, one that we're ready for and eager for and keep asking ourselves, "HOW THE HELL IS THIS NOT HAPPENING!"—is stalled.

But we now know how our arts organizations fail, and why. We know the systemic factors that affect these things. We can re-double our efforts. We can do better.

Constitutions

I love new technology. I don't really know how to use it, but I love it. I've got as many 'friends' as Facebook lets me have. I am a grandmaster of Kickstarter. I Air BnB the living fuck out of my warehouse. I pay my parking meters with an app. I'm trying to get a cloak made out of light bending fabric, but the military won't return my texts. The board of my non-profit, the San Francisco Institute of Possibility, debates what kind of teams benefit from using Slack and what kind are better off sticking with Hangouts.

Technology is great. It makes the world better. I want more of it. But I bet a lot of you are thinking, "If Chicken's talking about a whole new approach to organizing arts organizations, it must be some radical new communications technology! With the screens! And the mobile! And a killer User Experience! Is it a startup? Can we invest? Will it disrupt whole industries? Whole continents? Are Millennials using it?"

And...no.

Just no. Just stop it.

I will yell at you.

For twenty minutes. It will be terrible.

Because saying, "Oh! We have a new technology, and if we just use the new platform, that will fix everything!" That? That's how machines work. It's like a company with a crappy corporate culture saying that using a new email interface will fix their sexual harassment and pay equity problems. It won't. It's just an email interface.

Now, creating an app that provides all the salaries, qualifications, and years experience of all the employees might help with that pay equity problem—but that's not actually about the technology, right? It's about openness, willingness to share information and then act on it. If you've got those things, you don't need a new software platform; you can use a pen and paper. Hell, you can use a chalkboard. You can carve it into stone tablets. If you don't have those things, then designing an app for information that people won't provide—or will lie about, or will ignore—will not help.

Get it? Machine system problems, problems of the *UN*, can be solved with new technology. *IS* problems, organic system problems, creating inspiration or *duende* problems, can be solved by banging two rocks together, if you do it so rhythmically that

other people are inspired. And you don't even need the rocks. Because what you're talking about is a culture issue. If we practice working outside the mechanistic system, we will already be well-versed in organismic problem-solving when our current systems inevitably break down. And artists are already way ahead of everybody else.

So how do artists and groups in movements doing good works keep it all together? What does that glue look like? It looks like a global thesis outside of consequence or obedience, written open-source and implemented on a small scale as an experiment. Duh.

DYSTOPIA= CACATOPIA?

SORTITION [ALSO REFERRED TO AS STOCHOCRACY] IS THE ORIGINAL DEMOCRATIC MODEL FROM ANCHEINT ATHENIAN GREECE. IT'S WHERE PEOPLE PUT THEIR NAMES ON LOTS AND SOMEONE DRAWS A LOT FROM THE BUNCH AND BOOM: YOU'RE IN THE SENATE. USED BY THE FOUNDING FATHERS TO DETERMINE WHO WOULD GO SPEND TWO YEARS IN CONGRESS.[†]

THE BULLSHIT WE HAVE TODAY WITH OUR LEADERS MAKES ME WONDER ABOUT HOW RELEVANT OUR 240-YEAR-OLD DOCUMENT IS SOMETIMES. GERRYMANDERING, CAMPAIGN FINANCE, THUGGISH PARTIES THAT ELIMINATE ANYONE THAT ISN'T IN A PARTY'S GRACES...I LIKE THE CHAOS MODEL OF SORTITION WAY BETTER. C'MON, ELIMINATE POLITICIANS? WHAT COULD POSSIBLY GO WRONG!

THE POLAR OPPOSITE OF AN *ARISTOCRACY*, [WHICH WOULD BE RULED BY 'THE BEST'], IS A KAKISTOCRACY [WHICH WOULD BE RULED BY 'THE WORST']. OR EVEN WORSE: KLEPTOCRACY [GOVERNMENT BY THIEVES].

I'D RATHER BE IN AN ARTOCRACY. TELL ME THAT WOULDN'T BE FUNNY. WE COULD BE IN A MAGOCRACY, AND ALL BE RULED BY A SORCERER!!

IT'S ALL JUST BIDING OUR TIME UNTIL WE IMPLEMENT OUR UNIOCRACY. THAT'S WHEN WE WILL ALL BE A HIVE MIND THROUGH TELEPATHIC COMMUNICATION.

Let's write a constitution!

What is the difference between a constitution and a list of rules or a set of guidelines/principles? Simple. A constitution is a list of privileges and rights and restrictions. A list of principles, rules, and guidelines is vastly different. Rules and guidelines

are things you are supposed to obey just because. A constitution sets out the terms of citizenship. It defines a sovereign space, your rights and privileges within it, as well as your responsibilities to it. Rules are one way. Unipolar. Constitutions create multipolar relationships—between not only the citizens and the rules, but between citizens and each other. It's all very civilized.

Any event, festival, group or even a relationship that aspires to be more than just a power play (or...wait for it...a real estate scam...) needs a constitution in some form. It makes a whole lot of things better. It makes a whole different future possible. But, right off the bat, it also creates a different kind of community.

Because if you just write a list of rules, instead of a constitution with privileges and rights, then all you have is a list of rules on top of the already-long list provided by the country, state, county, and city you are already in. You're just piling rules on rules, with no added relationships. And what kind of system is that, everybody?

Anybody who said, "Mechanistic!" out loud gets to go with me on a boat down the Mississippi River. It'll be fun. We'll talk about the lunar landing. I have some information that may surprise you...

But I digress.

Let's say you run a transformative festival, and you've got a long list of rules for everybody who wants to get their chakras aligned while listening to a guy who once gave a TED talk explain the neuroscience of better living through alien abductions. When you've got a pile of mechanistic rules, the only way to get people to enforce them is some kind of ejection. If somebody's breaking your rules, or even challenging them, the only thing you can do is warn him that he'll be kicked out. And then warn him again. And then again. And then, finally, either just let it go or kick him out.

Some community that is. That's top-down. It sucks. But a constitution, a way of saying not just, "here's what you have to do," but, "here's how you relate to the whole, here's where you are within your rights because—hey—you have rights ..." that creates an organistic system. That creates whole other kinds of relationships. It's multipolar, so it can't just be top-down.

What I have seen in the last thirty years (and especially in the last seven) is people trying to create simple governing structures that are not top-down. And it's beautiful. A lot of the efforts are freshman, but the heart is all there. And they don't realize that they're talking about creating constitutions, but I think that is where they are going. And they're totally getting there.

So time thinking about how constitutions work is time well spent. As Robert Tsai wrote in his book *America's Forgotten Constitutions*[†], the act of writing a constitution can "instill a sense of empowerment and a belief in political possibility." In this chapter I'll show you some examples of it.

Now maybe you're too cynical to care. Too old to complete the Jedi training. Maybe your energy for this has dissipated. Well, I beg you to reconsider your position. You hear older people say it all the time. "Such-and-such was better when I was a kid." Bullshit. Don't fall into that trap. I have shown you, proven it with citations, even, that things are better by leaps and bounds now. Things were different when you were younger, yes. They were more familiar. Totally. And sure, you may *think* you prefer it the way it was, but it's just another social pattern that re-enforces all the other ones. When you're in that "Get off my lawn" bullshit, you are just part of the machine. You are reading a script A MACHINE wrote for you. Stop it. The machine wants you to surrender to it. And make it hard for younger people to have any power to experiment and fail. The machine wants you to create rules that make things easy—just give in! Well...who said life was supposed to be easy? When did that become more important than struggling and learning and doing interesting things and making the world an adventure? Sure you could fail, but isn't any failure a risk that was worth taking? We have been poisoned by our pursuit of money and comfort and control.

We can totally do it

OK. I'm going to make an educated guess and say that less than 5,000 people have participated in the process of writing a constitution ratified by a government. I admit that this is a total guess. There have been 107,602,707,791 people who have lived on the Earth so far, according to the Population Research Bureau. (I guessed 700 billion. I was way off.) And most of them have been born in the last 200 years; according to the U.N., the global population never even hit one billion before the 1800's.

Constitution writers represent .0000000005% of the people who have ever lived (I didn't actually do the math. You should know that by now.) This elite group had a tremendous responsibility to their fellows. You would think that people would be attracted to this fellowship. They have contributed to civilization in the hugest of ways. Great honor is bestowed on the laureates of the Nobel prizes or the recipients of awards from prestigious institutions and organizations in academia. People who either write constitutions or collate them from various sources and implement them as a package have never been appropriately honored. Unless you're talking about the founding fathers of the U.S...those guys crashed their showboat into their grandstand! Those guys were marketing geniuses! I mean, they got in the whole school textbook thing early on, now they're HUGE!

Anyway, what I'm saying is: artists need to embrace this idea. For all the reasons. Every arts group no matter how small needs to either adopt or write a constitution somehow, in order to avoid the toxic life cycle of arts organizations that turns them into a real estate scam. Or worse.

I see this as an inevitability. And it is totally going to be a thing.

And once enough artists get used to writing constitutions, and every arts group has one, and their ability to create magic moments that change the world grows exponentially? Then maybe they're going to start imitating each other. Ripping each other off here and there. Taking the best part of each other's constitutions and using those. And when that starts happening, then suddenly you start to see a common constitution for the arts building up across organizations, and then across countries, and then across the world. Until suddenly you have a kind of commonly recognized global constitution for the arts and for artists that unites artists everywhere. Voluntarily.

You think it can't happen? You think constitutions across history haven't influenced each other that way? Because that's EXACTLY what's happened across history. It's why 'constitutional democracy' has become such a big deal. *Elected representatives, Checks and balances, Independent judiciaries*—these were all things that started out in one constitution as experiments, and then spread until at least the idea of them has conquered most of the world.

Still don't believe me? Here are some examples of how that's worked and what people learned.

Corsica

Monticello is the name of Thomas Jefferson's estate in Virginia. Have you been to Virginia in the autumn? The color palate of earthy deep auburns and burgundy and cherry blossoms always give me a feeling of resolve. Brisk winds and hearty foods eaten after sunset. Wine will warm you from the inside out. May I recommend a rosé? Jefferson's favorite. So much so, he named his estate after his favorite winery in Corsica that made rosé. Jefferson loved the wines of Corsica (and everywhere else!) While he was there in 1785 getting wasted on the rosé, he copied the Corsican Constitution of 1755 and sent it to his friends who took full credit for it when they wrote America's new constitution in 1787, and the rest is, as they say, history. Or close to history. Some people say that never happened. They say it's a coincidence that the constitution of the Corsican Republic (a democratic republic, check that out) has a lot in common with that of the United States (a democratic republic—there weren't all that many of those in the world back then, it was—what do you call it—*revolutionary*).

But come on.

Corsica is a beautiful place. I went there on my honeymoon, with my wife. I'd always wanted to go there because of the towers. Do you know about the towers? No? Oh. Well. Let me tell you, there are towers surrounding the island. Genoese signal

towers. They were a marvel of 16th century engineering. Classic, round towers with giant hearths on the tops surrounded by parapets. At the first sighting of an invading army the signal fires would light and within an hour signal fires would ring around the whole island (620 miles) readying defenses. 16th century cell phones! The towers were featured in a kid book I had when I was small, and standing at the top of one has always been dream of mine. I imagined notching an arrow behind the parapet, feeling the wind on my face to judge any correction I might need to make before I whip around and let fly my arrow to strike the heart of the invading Turkish corsairs' captain standing on the bow of his boat. I imagined that I would be defending the free people of Corsica from the tyranny of the Turks who wanted to carry off my fellow countrymen and make slaves of them. I was very impressionable as a child, I'm glad I was able to get that out of my system when I was 45...

Corsicans are tight-lipped about their history. At least when talking to me. They're a quiet people, it seemed. Really into charcuterie. Do you like charcuterie? Just kidding. The Corsican connection is their constitution, written by Pasquale Paoli. If it is true that our constitution in these United States was borrowed or even influenced by him, it's worth talking about here. Because it's important. Now listen, if the USA can take Corsica's constitution, then that sets a pretty good precedent. And as we look at how governments adopt constitutions or constitutional amendments, we can see that good ideas are borrowed all the time. Because surely the Corsicans got something from the Magna Carta, which borrowed concepts from the Romans, who borrowed concepts from the Greeks... I don't really think there is any new content for a document like that. But things can be refined. Updated. Mashed up. You can't keep a good constitution down!

I'm showing you some history of constitutional plagiarism, and I for one am all for it. From the original sortition of the Athenian senate to the rugged Corsican pork-chops to the USA and onward to the final destination of a common document outside of borders that gets us to true equality. How far off is that? 20 years? 200 years? It doesn't matter. We need to surrender to the inevitability.

Japan

General Macarthur, Supreme Commander of the Allied Powers, gave an ad hoc group of people who were basically standing near him four-and-a-half days to write the Japanese constitution following Japan's surrender in 1946. Japan's government had suggested there was nothing wrong with their current constitution, developed about sixty years before during the Meiji period and entrenching a feudal system that arguably went back more than 2,500 years. And, hey, you've gotta be impressed by a feudal system that lasted that long. Kudos, bro. But, is that really a helpful thing in the modern world? Can't we do a little better?

Macarthur's belief that Japan could do better put Beate Sirota Gordon in an odd power position. She was Macarthur's translator. One of a handful of people who were in the room doing the work crafting the document. She and economist Eleanor Hadley found themselves responsible for pushing that document towards the equality of the modern world, and they took it seriously. Was it because they were women in a pretty literal boys' club of the military high command? Gordon was one of the few Caucasians in the world to speak and write fully fluent Japanese, and Hadley was (to the best of my research) the only female economist of her time. So you think they took the question of whether Japan's constitution would force most of the population to be serfs, and all of the women to be subservient, a little extra seriously? Talk about the right people being there at the right time.

But can you imagine the pressure they were under? One day your job is a translator, and then literally the next day then you're writing a constitutional document that will affect the lives of billions and billions of people, and you have the opportunity to make women something other than livestock. Can you imagine? That's amazing. They did a great job too. Japan's was one of the most liberal constitutions of its day, and it has now lasted longer than the one they replaced. Today Japan is a stable democracy, one of the largest economies in the world, a respected player on the international stage.

I'm not saying the constitution can take all the credit for that. Japan gets the credit. But Beate and Eleanor did good, didn't they? They made it a constitution that made all that stuff possible. That's impressive, right? Come on.

I visited Japan once. I was there for nineteen hours. It is a shocking place.

Japan's constitution forbids them from using their army for any aggressive purposes. And it turns out that there are a lot of advantages to not being a colonial power. Without that absurd expense, they became a world leader in the sciences, industry, manufacturing and all manner of other things. When we see the standard of living they have and the advances they have made in engineering, medical and, well, everything, you begin to see how when a country's budget isn't eaten up by blank check military spending, there is nothing but possibility.

The Republic of Indian Stream

The what?

You're probably thinking, "Chicken, I've heard of Japan. Somebody once mentioned Corsica at a party. But what are you talking about now?"

This is a real thing, I promise.

We usually think of the American constitution as a 'once and done' kind of thing. A bunch of guys in powdered wigs got together and wrote up a constitution and then it was over and everybody dusted the powder out of their hands and said, "Thank God we never have to do THAT again!"

But that's not what happened. At all. According to Tsai (in *America's Forgotten Constitutions*)[†] the writing of America's 1787 constitution wasn't an event that the American people just sat back and consumed. It started (get ready for this) a whole movement for the idea that writing constitutions was a way to resolve problems. And as America, still a young nation, still a long way away from filling up the whole continent, experimented with different kinds of communities, everybody wanted to get in on the constitution writing act.

"The revolutionary fervor that culminated in the U.S. Constitution did not dissipate after the document's ratification," Tsai wrote. "Instead, as Gordon Wood describes, an impulse to challenge authority infected 'every institution, every organization, every individual. It was as if the American Revolution had set in motion a disintegrative force that could not be stopped.' Far from arresting this dynamic, the founding generation's ingenuity ushered in an age of political development and commercial enterprise in which higher law played increasingly elaborate functions. Americans authored state, local, and civic constitutions to liberate themselves from the past. When conventional political forms were not feasible or did not suit their needs, citizens initiated more ambitious experiments."

They wrote constitutions.

Which brings us to the people of Indian Stream, a community founded in 1832 between what is now Quebec and New Hampshire. To make a long story short (you'll thank me later) there was a border dispute about where the U.S. ended and Canada began, and Indian Stream was in the middle of the disputed territory—which meant that both New Hampshire and Canada (still England, back then) wanted Indian Stream to pay their taxes and obey their laws, but neither was willing to come to their defense or offer any support. A total catch-22.

When the people of Indian Stream realized that nobody was in a hurry to fix this, they took matters into their own hands. The wrote a constitution, and declared themselves a republic.

Mostly they ripped off America's 1787 constitution—and why not? They loved that thing. But the premise of their constitution, their philosophy behind it, was a little bit different. As Tsai says, "Their view of popular sovereignty was inextricably linked to territory; control of a parcel of land and productive work of it, rather than paper title, generated true authority to govern."

That kind of makes a difference, right?

Indian Stream only lasted three years. They got into a fight with the New Hampshire militia, things came apart, it's not a happy ending. But let's not lose sight of their accomplishment. When nobody would take responsibility for their welfare, they wrote a constitution and did it themselves—and it worked. They had a functioning, law abiding, society in between two superpowers, one that they cared enough about to take up arms and defend (at least until it got absurd). Indian Stream got shut down by an army because it worked, not because it didn't work. It failed, but it proved a point: people who have their own specific philosophies, their own ideas of where moral authority comes from, can actually make a functioning social order by ripping off somebody else's good constitution and making it suit their needs.

That's what's happening now.

The Icarian Nation

The Icarian Nation lasted a lot longer. But there are two reasons for that. First, they played it smart. Second, they weren't actually a 'nation' in any meaningful sense. Icaria was an intentional community, with a heavily international population, mostly from France, that settled in Illinois and actually got the Illinois state legislature to approve them as a legal entity. Not a *nation*, not by a long shot, but *a legal entity at least*. And Icaria lasted from 1848–1895. That's a pretty good run. You go build something that lasts that long.

Icaria's life was long, but it wasn't happy. It was a utopian community: equal rights for all, the abolition of private property—but it was also a conservative community. They kept getting into fights about how much women should be covered up. And these arguments got brutal—like, accusations of election fraud and power plays and lawsuits brutal—because they made one crucial mistake: they made a terrible constitution.

Just terrible.

What, did you think something like that doesn't matter? Of course it matters! Just because constitutions are a crucial component of successful 21st century arts organizations doesn't mean you can just slap them together! You need to borrow from people who have done it right! Steal intellectual property!

Instead of identifying the rights, privileges, and rules governing their sovereign space, the Icarians tried to make a rule for everything that came up. EVERYTHING. It was a shitshow. Check it out, this is from their constitution: "Because the people are sovereign, they have the right to regulate, by their constitution and laws, everything pertaining to their persons, actions, goods, food, clothing,

lodging, education, their work, and even their amusements." Not only that, but "every work of art is created with a utilitarian goal." And, oh yes, every citizen was supposed to be a policeman: it was a crime not to report a crime, however small, however trivial. In fact, no shit, "Each family constitutes itself as a court of justice to judge family misdemeanors... There is no area where the courts and justice are not in existence."

Holy fuck was this not a place I'd want to live. But, you know, it wasn't for me. It was for them. They were doing their thing. And that's fine and all, but it was destined to fail—like the Titanic hitting an iceberg destined to fail—because their constitution was so terrible. It's not just that nobody likes to live in a police state, or that you can't ask family members to turn each other in for littering, and that if you try to tell artists that they can only create the art you tell them... well, that's never going to work. But the problem was deeper than that. The problem was that they tried to make their constitution answer everything—which not only meant that they were a nightmarishly rule-bound society, but that every disagreement anybody had was a full-blown constitutional crisis. There was no way to disagree about what color to paint your dining room without challenging the legitimacy of the constitution.

And that's so backwards it can eat food with its ass. The point of a constitution is to make it possible to disagree and have arguments in a way that doesn't tear the community apart, that even strengthens it. Remember: rights and privileges. Any constitution that doesn't emphasize those as much as rules and order is going to fall apart.

The World Constitution

Actually there was an organization, back in 1948, that created a whole global constitution. Something for the whole world. The idea was that nuclear weapons were really scary— remember, two of them had just ended the biggest war anybody had ever seen, society was still reeling—and a lot of really smart people were pretty sure that if we didn't make some major changes to the world, and fast, the next war would destroy everybody.

So they figured world government. Why not give that a try?

They came up with the constitution at a conference in Chicago—maybe not the best start, maybe they should have held a few more meetings outside of the neighborhood—and they pulled from everything they thought had worked. The American constitution, sure, the Federalist Papers (always popular), the French constitution, and a whole lot more stuff. Here's Tsai on this bad boy, "The World Constitution imposed a handful of duties on individuals, something the 1787 American Constitution never attempted. New duties included each citizen's responsibility to engage

in 'productive labor according to his ability,' abstain from violence except to 'repulse violence,' and 'do unto other as he would like others to do unto him.' Citizens of the World Republic were charged to work for the 'spiritual and physical advancement of the living and of those to come.' These provisions, fulfilling the Chicago group's goal of attacking nationalism as a source of selfishness and violence, amounted to a limited ethical intervention. These values can be seen as glosses on traditional liberal and republican values: self-control, equality, self-defense, virtue. Moreover, it is not apparent whether these were enforceable commands or merely aspiration. The drafters overriding concern for broad consensus and the politics of ratification suggested the latter."[†]

As constitutions go, it was pretty good. It divided the world up into a bunch of regions and each region got votes on a bunch of different councils, all the councils rotated so no region could take permanent control, they had checks and balances, respect for individual liberty...hey, a lot of people have lived under a lot worse. It actually began with a Declaration of Duties and Rights, which is exactly that: here's what you have to give up, and here's what you get.

The only real sticking point for it was that nobody except the world government got to have an army. Nobody. Disarming the nations of the world was the whole point: only we get to have the nukes. I don't know how you feel about that, maybe it's not the worst thing in the world, I don't know. But it's reasonable to be scared of nukes. That's, in the scheme of things, an okay thing to have anxiety about. Snakes don't seem all that scary, really. Public speaking is no big deal. Nukes? That's a big deal.

So, pretty good.

But the reason you didn't know there was a world constitution, of course, is that the world never adopted it. No, you didn't miss that. You're not that badly informed about world events. What happened instead was that the U.N. got founded and stole a lot of the 'world constitution's' thunder, and the Korean War started and it's a lot harder to unite a world at war than at peace, and the whole 'anti-communism/anti-capitalism' thing really picked up, and that was kind of a problem for the idea of everybody just starting a single government...there are still people pushing the world constitution today, if that's your thing. You can still totally go to meetings of the United World Federalists if you want, push for that world constitution. They've got chapters, and a think tank...don't you wish your movement had a think tank?

But come on, it was never going to work. I mean, even if none of that stuff had happened—no United Nations, no Korean War, no cold war—it never would have happened. Not because a world government isn't possible, I totally and completely believe it is possible, and you will be AMAZED at how quickly it happens once all the pieces are in place. Just watch. It'll be incredible.

But...no...this world government was never going to happen. Not because they didn't have a good constitution, but because the global constitution was written by a bunch of academics sitting around a table in Chicago.

I love Chicago. It's a great town. But to paraphrase Tertullian: what has Chicago to do with Moscow? Or Mozambique? Or Beijing? Or Manilla?

I mean, come on. The natural reaction of the world to the World Constitution was always going to be, "Oh, you wrote us a constitution? That's nice. We'll put it up on a wall somewhere. No, we totally will! We will totally put that on one of our walls! If you ever stop by for Christmas, you'll totally see it! Just give us a little warning, okay? Don't drop by unannounced or anything."

The people trying to save us from nuclear annihilation with a world government had a constitution...but not a global movement. There were probably a lot of people around the world back then thinking, "Hey, a world government is actually a pretty good idea." There are probably a lot of people thinking that now. Maybe you're one of them. But if you are, I bet you have never, ever, thought, "Hey, I want a small group of elite academics to write a global constitution at a conference in Chicago, and then we'll totally do whatever they say!"

I bet that idea never even crossed your mind.

No, if there's ever a real movement for a world government, it will be a *movement*, meaning people will want to actively participate in it, help create it, relate to it in ways beyond just saying, "okay, we'll do what we're told." (That's just consuming what you're given.) It will be people in all the places that will end up being governed jumping up and down with excitement about all the better ways they've come up with for their government to work.

That's what will need to happen before a world constitution makes any sense. And they didn't have that. They weren't that. But, they did demonstrate something important: they did steal what they thought were all the best pieces and parts from all the constitutions and political philosophy and historical documents that came before. They showed us just how far you can get, by creating a constitution with the understanding that cultural history belongs to you and can totally be repurposed. For you. By you.

Which is great. Once that catches on...magic.

Constitutions—It's Not Just for Governments Anymore!

So that's a fun look at some government constitutions—the good, the bad, and the

stupid. There are a bunch more. Every state in America also has a constitution. Most *functional* countries in the world have constitutions of some kind. They're all over the place. But they're for governments.

And okay, let's not complain about that. Constitutions are great for governments. They've made them so much better. But they can work magic for other kinds of organizations, too. And that's where the world gets really interesting.

Take a look.

Ephemerisle

Maybe you don't believe me that festival culture is hungry for experimenting with governance and constitution writing. Well. That's because you haven't gone to the aquatic shitshow known as Ephemerisle. They've got it bad. A leaderless collective of people pointing at each other screaming, "He's in charge!" No one want central power or liability. But boy does everyone want their say. And what they are saying is pretty interesting. But the *way* they're saying it is actually totally fascinating and worthy of paying attention to. You've never seen a more ham-handed attempt at open source government. It's just baffling that it works. But it does. Barely. Because their intention is to experiment, not to succeed. And they totally give 100%. And fail. It's an Engineered Disperfection. And it's fucking funny and messy and confounding and beautiful.

It was originally supposed to be a gradual experiment in learning how to build ocean-worthy platforms that people could live on in glorious wild freedom, a weird libertarian techno-fantasy bankrolled by Peter Theil, one of the clowns at the Republican National Convention who told us we need to make Donald Trump president...

...Thanks, Peter! You're a real humanitarian! And now, for the rest of your life, you get to be remembered as a guy who lined up to push Donald Trump! How's that gonna feel when people are still talking about it in 20 years, and it finally hits you that this is going right into your obituary, right after the thing about PayPal that no one is going to talk about, and just before the thing about Facebook that is going to be completely overshadowed...

...but hey, most of the best things in life stopped being what they were 'supposed' to be, and now hundreds of people are renting houseboats (totally dominating and disrupting the houseboat-rental economy of the Sacramento River Delta) and getting their crazy sailor-y friends to bring their sailboats out and giving free shaky catamaran rides to gleeful revelers. Then there is the handful of people who arted up their boats into sort of back-streets-of Burning-Man-at-3a.m sort of sad/glorious floating light and music parties (except unlike the relatively harmless boring

backstreet theme camps at Burning Man, you could fall and drown or get crushed between boats or, more important, get trapped on a party with no boat to get back in), and they rented (or stole?) some giant chemical dump barge and then built an absurd 'party barge' with kindergarten carpentry that actually is making the rusted old giant chemical waste barge LESS safe than when they got it, AND they are indeed making painted EDM dance floors in the water (glossy painted plywood on inflated inner tubes which, when they eventually shatter, and they will, is going to drown people) with janky floaty walkways that hang off of leaking inner tubes—and everyone with a boat who is a little bit off, or unusual, or broken, in northern California is coming on out to…float. And ride around and bump into each other and climb on each others' boats and eat each others' food and maybe mangle each others' limbs. And now the moon is up and the places we are standing and talking and getting high and boogieing down and cooking and laughing and all that are all just floating around and hey jump on my boat I'll take you over to that other boat and then you are stuck on that other boat… and every moment you are inches or at best feet away from water and the safety and security of the very ground under your feet depends on the anchoring and knot-tying capacities of a lot of some very dedicated partiers whose conversations sound like a bingo game where the card reads 'polyamory,' 'meow mix,' 'bitcoin,' 'lifehack,' 'paleo,' and 'drug legalization'… **but** they haven't lost sight of the whole political science fiction dream that got them trapping themselves willingly in this impossible-to-escape Tijuana of a Waterworld……

Am I making it sound as great as it is? I hope so… so I ask you: what could make a party of constant life-threatening hazards better except having to have deep druggy conversations about *consent* before you are allowed to risk falling off their shoddy 'carpentry'…?

Well. It's like this. You see, certain islands make you sign a waiver and a form that clearly states what consent is. Like, straight up, a guy tells you to your face that if you would like to touch someone you have to look them in the eye and ask if you can. All I could think about was how cynical I was that my default feeling was to think, "Criminals don't obey laws." Or, "This doesn't apply to me. I'm not going to touch anyone." But it does apply to me. Because this is their island and if I want to come on it I have to sign the waiver and listen to the guy in fun fur pants and a rainbow wig tell me to keep my dirty mitts OFF. And they want to be able to say that they gave *everyone* the same schpiel. That *everyone* signed the waiver that is totally not legally binding in the state of California. Sorry. Other islands have different ideologies or rules. Of course it's hard to know them. They're not really written down anywhere. I told you it was a shitshow.

Ephemerisle can not scale. It can't get bigger. It can't be monetized. It's in the middle of the delta next to a shipping lane. There would be no way to set up a gate and collect money. They pay for things with fundraising sites and donations. No central

organizing structure. Another leaderless collective populist art gathering. They're popping up all over. It's hands down the most dangerous thing I've ever been to. It's a miracle that shit doesn't get hard and go sideways. But ya know, in that risk is the very ore of the human condition. Or something.

This is something I picked up from the Ephemerisle page:

> *"Trust is earned, not freely given out to ostensible strangers. Without a 'constitution' that stipulates rules of engagement, chaos and natural disequilibrium will occur. The rules (especially as it relates to consent) are railguards set up to dissuade 'bad actors' will ruining (sic) a good time by all."*

So some islands at Ephemerisle are becoming their own, brief, constitutional systems. Written out, established, and voluntarily accepted by everyone who steps foot on that sovereign territory. They're doing this. This is happening. And what I've seen, over the years, is people taking parts of each other's constitutional styles and stealing them, while other parts they are staying far away from. So that while there are endless unique constitutions, and some of them are really bizarre, maybe next year a few islands will agree on a common document. So Ephemerisle is developing elements of a common constitution, all on its own, without even trying. I wonder how many other events are doing the same thing using the miracle of parallel evolution? The mind reels...

Pirate utopias[†]

While we're talking about Ephemerisle, it's worth pointing out: pirate utopias probably existed. Pirate utopias are kind of like Ephemerisle and also not like Ephemerisle: they're when people drop out of society in the 1700 and 1800's and get a boat and raid and pillage and do all the nasty piratey stuff. Be hearty seamen.

Not like Ephemerisle.

But then they go back to their secret island in the Caribbean. Where they argue politics and experiment with different models of organizing their secret island governments. They were probably polyamorous and very likely followed the 'paleo' diet.

See? Like Ephemerisle!

Can you image the council meetings? On a Caribbean island paradise with a group of dropout pirates? History is impoverished that there was no Boswell there. I'll bet they came up with some cool shit.

I wonder if any of those people from any of those places ever ended up back in society. And if that happened, if any of them continued their interest in governmental forms. And if they did, is it possible that those ideas ended up being adopted in the

places they settled in and were they copied by others to end up here with us in our American charter? Or by the miracle of parallel evolution they were the first people to call for a global constitution? If today I'm singing the same song does that somehow make *me* kinda a pirate? God I hope so!

Pirates building utopia, what can be better than that?

Burning Man

Burning Man came so close to being the art revolution we need. So close. So painfully close.

You should imagine me with an empty bottle of bourbon in my hand and three days of stubble as I type this.

So close.

But when the time came for Larry to write a constitution for a new kind of art movement and create the civil society around it, he wrote the 'Ten Principles' instead.

sad trombone sound

A long time ago, I presented him with an argument for three things that our community needed: voting, membership and a constitution. I've been debating with Larry about this for twenty years. (Twenty years!)

To be fair, Burning Man's gotten really successful since he wrote those Ten Principles in 2004. The event's just gotten bigger, and more famous, with more ticket sales, and more expensive tickets, and a big bunch of people donating money. Hey, they even bought real estate!

Sound familiar?

Let's assume that, for the purposes of this book, that their view of civics is one of empowerment for the citizens. Let's also assume that they see their event as occupying sovereign space where they would like liberties and freedoms to blossom and help their citizens create that magic environment that summons *the duende*. Let's assume that their intentions are good. Let a thousand flowers bloom!

Before synchronized eye rolling turns into synchronized face palming, let's examine Larry's Ten Principles, listed here, and consider them afresh:

Radical Inclusion

Anyone may be a part of Burning Man. We welcome and respect the stranger. No prerequisites exist for participation in our community.

Gifting

Burning Man is devoted to acts of gift giving. The value of a gift is unconditional. Gifting does not contemplate a return or an exchange for something of equal value.

Decommodification

In order to preserve the spirit of gifting, our community seeks to create social environments that are unmediated by commercial sponsorships, transactions, or advertising. We stand ready to protect our culture from such exploitation. We resist the substitution of consumption for participatory experience.

Radical Self-reliance

Burning Man encourages the individual to discover, exercise and rely on his or her inner resources.

Radical Self-expression

Radical self-expression arises from the unique gifts of the individual. No one other than the individual or a collaborating group can determine its content. It is offered as a gift to others. In this spirit, the giver should respect the rights and liberties of the recipient.

Communal Effort

Our community values creative cooperation and collaboration. We strive to produce, promote and protect social networks, public spaces, works of art, and methods of communication that support such interaction.

Civic Responsibility

We value civil society. Community members who organize events should assume responsibility for public welfare and endeavor to communicate civic responsibilities to participants. They must also assume responsibility for conducting events in accordance with local, state and federal laws.

Leaving No Trace

Our community respects the environment. We are committed to leaving no physical trace of our activities wherever we gather. We clean up after ourselves and endeavor, whenever possible, to leave such places in a better state

than when we found them.

Participation

Our community is committed to a radically participatory ethic. We believe that transformative change, whether in the individual or in society, can occur only through the medium of deeply personal participation. We achieve being through doing. Everyone is invited to work. Everyone is invited to play. We make the world real through actions that open the heart.

Immediacy

Immediate experience is, in many ways, the most important touchstone of value in our culture. We seek to overcome barriers that stand between us and a recognition of our inner selves, the reality of those around us, participation in society, and contact with a natural world exceeding human powers. No idea can substitute for this experience.

Now, principles are great. Everyone should have a few. They provide guidance and direction and they're probably good for morale, but they really don't give rights or privileges. Well, maybe they do a tiny bit. You could shoehorn a right out of something on that list. You could squeeze out a privilege or two, maybe. But this document reads more like it belongs in the self-help section than the governmental policy section, and 'principles' give no equity in a society. They do nothing to prevent an art group, no matter how amazing, from turning into a real estate scam. Burning Man is a top-down organization, for better and worse. And the Ten Principles are a cog in that very successful machine.

In the early days of Burning Man if you asked anyone involved if there was some kind of charter or some kind of agreement between all the people there, the response would have been a resounding affirmative—even though no two people would have agreed on what it was.

This is what happens early on in every successful arts organization: everyone fills in the blank canvas with assumptions and their ideas of how every should work, and for some reason they assume that everyone else thinks the same thing. I've seen it happen my whole life.

At Burning Man, it happened on a mass scale. From 1994 to about 2003, any newcomer to Burning Man—and there were tens of thousands of them—would instantly assume the event was run by a non-profit and everyone was a volunteer.

That was sorta true. It was never a non-profit (back then, it is now) but everybody there definitely was a volunteer—until a small group took over (mitosis) and drew salaries and started employing staff, and took a payout when they 'sold' their compa-

company to their own non-profit, that they're still running (it makes my black little carny heart swoon when people engage their criminal minds!)

But...but...okay...a lot of people still go there, more than ever, and a lot of people still say it changes their whole lives, and the organization gives some money away... is this really so bad? Is it so bad that it's become a real estate scam that's enriched a few people but brought joy and some nice big art to a bunch of other people (more and more rich people, these days, but still...people), and everybody wears costumes and goes a little crazy? Is that so bad?

No! That's not the worst thing in the world. You could argue that it's very, very good. But it's definitely not what we were working for when we built the thing, and it's definitely not the art revolution the world needs, and...in my humble opinion... it's definitely not what it could have been.

If you're happy with what Burning Man is now, then you're saying that you're happy with a very neat, very tidy, repeatable, mediocre *Monarchy*. And I'm arguing that we need a risky, messy democratic shitshow with a constitution that could be adopted (in part) by other festivals (or nations!) and NOT open to the public (because it's a private club) because everyone who gets there is a member/citizen. I'd argue that because I think that would be better. At a level of magnitude not measurable by any tool I am aware of.

C'mon, did you think that the big questions about Burning Man were really how to throw a better party? Do you really think that you could get all those people to have volunteered so much time and effort if they didn't think that by contributing they were changing the world somehow? There's no way. People know that what they do there matters, even if it seems like it's just a massive playground.

Don't underestimate playgrounds.

Johan Huizinga has a whole theory on the importance of play for the generation of art and culture. In 1938, he wrote a book called *Homo Ludens*.[†] He insists that humans played before they generated culture. So it makes sense that if we are manufacturing culture or if culture is shifting, it will happen through play. He also originated the term 'magic circle' which I could tie into *duende* if this wasn't the constitution chapter, but it is so I won't. Now, listen to me: activism doesn't have to be angry sign-wielding chanters blocking freeways. When the yuppie–fantastic men's apparel shop Jack Spade was going to put an over-priced formula retail store on 16th street, we told them we would get, "Jack Off 16th Street" and we would, "Fill The Streets With Seamen!" and then we all just wore sailor suits to the 'protest.'[†] And they ran away screaming! My novelty vomit powered 'Puke-In' to protest the privatization of Dolores Park was totally real, totally play, and totally worked. It wasn't that we had fun staring the system down—we were able to stare the system down *because* we were

having fun. Hell, Occupy was at its best when it was a bunch of people having fun that anyone could join as they ground whole cities to a halt, and it was at its worst when they were a bunch of dour, humorless, activists insisting that laughing was counter-revolutionary.

The list goes on! Look at the 'Culture Jammers' and their body of work. There are so many people doing things that they love to do AND that could be totally considered activism. People who are seekers, dreamers, and mad explorers of the human condition all contribute to Burning Man as a kind of activism. Their play is activism. To me, there is no other way to see this. And if you think that I am misguided, wrong, insipid, bathed in vileness or just naïve, that's fine. The point is that it still isn't just entertainment. What they're doing isn't a product you consume. It's important. Their identity is attached to it. It helps them seek betterment for themselves and for the world. It fills a void in their lives. To many of the people who go to Burning Man, it's the most important thing they do.

It's a movement. One of the most amazing movements of our time. It is a great thing. A complicated, giant mountain of puzzle pieces. It's a miracle if you can even get two to fit together.

Burning Man is now set on a path now that I don't understand or pretend to. I'm totally disconnected. But during that time when I was very connected, I saw a fork on the path it was on. And I did everything in my power to get Larry to take the road that has a constitution that gives rights and privileges and democratic participation. The road with the risks: *Community Road*. A road that was going to be hard. He wanted to take *Easy Street*: with the plug and play camps, as many people as possible and his total control of everything. A path that ends with BM becoming a bucket list event with plenty of money and a formula and a revolving door of volunteers and a predictable, repeatable mediocre system that is a shadow of what it could be. I could not get him to change his course then because I didn't know what I know now.

There was a time that we could have done ANYTHING. In the early times (I'm not saying 'back when things were better' or any of that bullshit, I just mean, when it was still picking up steam) there was a window where we could have implemented anything we wanted. The path that I was pushing for would have been these three things: a **constitution**, **membership** and **voting rights**.

A constitution:

Writing a constitutional document as a community project hits collaboration, communal participation, civic participation and a few other things on the list perfectly. Having a 'bill of rights' would help with a bunch of things like agreements for photography and other issues of consent, with ticket allocation, and with your rights regarding artistic censorship. It would have been an intellectual exercise for ALL of us instead of just having one guy set the tone for everyone there. You had all these

amazing people, the people who actually made the culture, there all begging to contribute, LET THEM!!!

Membership:

Membership has many benefits, from establishing social capital to effectively managing lineage to getting people to invest. Membership would create many more options for handling ticket scarcity, including a vetting process, so everyone involved has social capital 'skin' in the game and we are taking care of each other. New people would have to be adopted into camps and communication and fundraising. Awareness and 'calls to arms' would be streamlined.

Voting rights:

Well, it made sense to me that if we were a city, we should get to vote on some stuff. Not everything. Certainly the art. Maybe one board member selected by sortition? Voting would build engagement. Eventually, the civic community could vote on constitutional amendments when appropriate through initiatives. Larry looked at me like I was a raving lunatic frothing at the mouth. "Why would I do that?" he said. "Because it will be fun. And it's the right thing to do," I retorted. "I'm not a hippy. I run a city," he said. Yeah. The only city in the U.S. that doesn't have voting rights.

There was a time when we could have done all this. And it would have been messy and it would have been difficult and maybe Burning Man would have ended up being only half as successful monetarily. Maybe it would have exploded and ended. Maybe it would have been terrible. But its success would have meant that this year would have been year twelve of experimenting with a constitution that could be adopted by other events and maybe we would start seeing some of those ideas spilling into government. If it happened and it didn't explode, I think it would be 10,000 times better than what we ended up with. Sure, there is risk in all things. This was worth that risk. To me. What we have here now is fine. I guess. I don't want to sound spoiled. The window has closed for these things. And they have to be let go.

We can't go back to that time, we have to wait for other windows to open. Burning Man had this opportunity, and they took another road. I know that's an oversimplification, but it's true.

But Burning Man still proved that it CAN happen. That it is possible to create that ecology of magic moments. Think of it as a practice run. We got really close, and discovered that no one had any practical experience dealing with that much magic concentrated in one place. So it didn't work out. Half the time I think, "it should have totally worked" and the other half I think, "of course it wasn't going to work." Even though it's still pretty amazing, for what it is. It's a populist art gathering on a dry lakebed in the middle of nowhere. People love it.

The two paths of Burning Man

OK, how do we put Burning Man on the Failgraph? After all these years, here's my chance to crush them! I get to use my stupid little graph to show how they did it all wrong!!! Here it is:

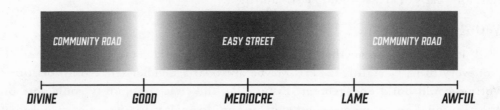

Man, did that feel good.

CAPT RAY

LET'S TAKE A BREAK FROM BASHING BURNING MAN FOR A MOMENT, SHALL WE? I MEAN,
IF THERE WASN'T ANY MAGIC THERE THEN AREN'T I A FOOL TO HAVE SPENT SO MUCH TIME
SHOVELING SHIT AGAINST THE TIDE? LET ME TELL YOU ABOUT MY FRIEND, CAPT. RAY...

I WANTED TO BUILD A TABLE FOR BURNING MAN ONE YEAR. THREE OR FOUR HUNDRED FEET LONG.
WITH PROPANE FIRE LIGHTS EVERY TEN FEET AND BENCHES MADE OF STACKED UP JUNK TIRES
SCREWED TOGETHER WITH LONG PLANKS ON TOP. THE TABLE WOULD BE CAST OUT OF CEMENT
THAT WE WOULD MAKE OUT OF PLAYA WITH STRAW, SAND LIME AND GYPSUM. FOUR FEET WIDE,
FOUR HUNDRED FEET LONG. I IMAGINED MOSAICS IN THE TABLE MADE OUT OF JUNK TILE, GLASS
AND OTHER TRINKETS. MAYBE IT WOULD TELL A STORY OR MAYBE WE COULD GET SOME LED LIGHTS
ON THE CHEAP. THE IDEA WAS DINNER THEATRE. YOU BRING DINNER AND WATCH BURNING MAN.

FROM THE PROPOSAL: "THE TABLE THAT IS IMPOSSIBLY LONG IS ALSO IMPOSSIBLY STURDY. IT'S
CLEAR, THICK TOP IMPRISONS A MOSAIC OF BROKEN GLASS AND JUNK THAT TELLS A STORY

IN A LANGUAGE OF GLYPHS, FOR ANYONE WHO HAS THE TIME TO PUT IN TO WALK ALONGSIDE THE TABLE AND WATCH THE LIGHTS ILLUMINATE THE PANELS AND HELP TO TELL THE STORY EMBEDDED THERE. DINNER IS SERVED BY HUNDREDS OF STRANGERS TO HUNDREDS OF STRANGERS BY THE WAY OF HUNDREDS OF STRANGERS. PASS THE SALT. PASS IT DOWN BUT DON'T EXPECT IT TO COME BACK BECAUSE THERE IS NO WAY. OPEN FLAMES BARELY LIGHT THE TABLE TOP FOR NIGHT TIME EATING BY WAY OF CANDLE OPERAS. THE TABLE REPRESENTS ACTUAL COMMUNITY, FOR IT IS THE SIMPLEST FORM OF A COMMUNITY CENTER. THE PIECE JUDGES NO ONE. NO ONE CAN BE BETTER AT IT THAN SOMEONE ELSE. IT'S A PRETTY TOOL. PEOPLE WILL USE TO DRAW ON AND READ AT AND BUILD SHIT ON AND ALL THAT. AND EAT ON. AND MAKE OUT ON. GET A BETTER VIEW. SHADE. WHATEVER. IT'S A TABLE, THE MOST COMMONLY FORGOTTEN THING AT BURNING MAN."

THE FUNDRAISER I DID TO RAISE THE MONEY TO BUILD IT WAS A DISASTER. *ROCK THE BOAT* WAS THE NAME OF SHOW I DID AT KELLY'S MISSION ROCK DOWN BY 3RD STREET AND 16TH. THE VENUE IS ON THE WATER. YOU CAN SIT AT A TABLE AND WATCH THE SHOW I CURATED ON BOATS. I JUST DIDN'T REALIZE HOW HARD IT WOULD BE. IT WAS MY FIRST BOAT THING. AND EVERYTHING WENT WRONG. THE VENUE WAS NERVOUS BECAUSE THEY HAD HEARD HOW WILD AND CRAZY "BURNERS" WERE. SO THEY HIRED LIKE NO SHIT 15 SECURITY GUARDS. ALL MUSCLEBOUND BEEFCAKE STEROID MARINA DOUCHEBAGS. THEY LITERALLY LINED UP IN FRONT OF THE CLUB AND "SEARCHED" EVERYONE BEFORE THEY CAME IN. SOME OF THE SECURITY LUNKS WERE DRUNK. MANY PEOPLE WOULDN'T GO THROUGH THEIR GAUNTLET. I HAD NO IDEA, I WAS TRYING TO SET UP DRUMS ON A BOAT WITH NO FLAT SURFACES. EVERYTHING WENT WRONG. SHIT WAS FALLING IN THE WATER, THE VENUE HAD ESSENTIALLY SCARED EVERYONE AWAY, SO EVERYONE WAS IN A FOUL MOOD. THE LIGHTS I HAD SHINING ON THE BOAT WERE BLOWING THE CIRCUIT. THE BAND'S AMPS WERE PLUGGED INTO EXTENSION CORDS THAT WERE IN THE WATER. EVERYTHING WAS LATE. I HAD A $5,000 BAR GUARANTEE WITH THE VENUE. I ENDED UP LOSING OVER $3,000.

IT WAS KINDA WORTH IT, THOUGH, BECAUSE THROUGH THAT EVENT I MET CAPT. RAY. I REACHED OUT "HEY, ANYONE KNOW ANYONE WITH A BOAT WE CAN USE FOR AN EVENT FOR THE BURN?" I GOT HIS PHONE NUMBER AND EXPLAINED THE IDEA OF THE SHOW. I'M SURE IT SOUNDED AMAZING. I WOULD GIVE HIM TWO TICKETS TO BURNING MAN IN EXCHANGE FOR HIS BRINGING THE BOAT THAT TWO BANDS COULD SET UP ON. HE HAD NEVER HEARD OF BURNING MAN. HE WAS INTRIGUED. CAPT. RAY IS A ONE IN A BILLION GUY. HE'S A SAILOR. EVERY OTHER BOAT IN EVERY MARINA IS NAMED *MANANA* (TOMORROW), SO HE NAMED HIS BOAT *HOY HOY* (TODAY!). A FAIR, PRINCIPLED MAN OF DEEP CONVICTION AND FEW OPINIONS. READ THAT LAST SENTENCE AGAIN. THE GUY IS A UNICORN. ANY TIME I SPENT WITH HIM WAS PRECIOUS AND MIRTHFUL. HE HAD DONE A MILLION THINGS IN HIS LIFE AND HIS STORIES WERE AMUSING AND ANIMATED. ONE DAY AFTER KNOWING HIM A WHILE, I DISCOVERED HE HAD A SECRET PASSION. HE WAS INTO FAIRIES.

NOW, THIS IS A BIG MAN. HANDS LIKE SMALL TURKEYS, LEATHER BOOTS YOU KNOW HE OILS EVERY WEEKEND. HE'S THE KIND OF MAN WHO EATS A GIANT SANDWICH AND SAYS, "WELL THAT JUST GOT ME HUNGRY NOW." HE'S A TOOL GUY. A TRUCK GUY. HIS BOAT WAS BUILT IN 1950, IS MADE OF MAHOGANY AND IT'S LIKE A FLOATING MUSEUM. AND WHEN HE STARTS TALKING ABOUT FAIRIES HIS EYES LIGHT UP AND MISCHIEF COVERS HIS FACE. IT'S LIKE BEING TRANSPORTED BACK IN TIME A THOUSAND YEARS, YOU CAN IMAGINE, IN BETWEEN THE WARS OF THE SAXONS AND THE NORMANS, A MAN SITTING ON LOW TREE STUMP TELLING A STORY TO A GROUP OF YOUNGLINGS WITH WIDE EYES AND OPEN MOUTHS OF HOW THE FAIRIES USE TOADSTOOLS TO LEAVE SECRET NOTES AND IF YOU KNOW HOW TO READ THEM YOU CAN CATCH ONE AND MAKE HIM GRANT YOU A WISH. HE LIKED TELLING FAIRY STORIES. AND THERE'S NO WAY ANYONE COULD HAVE SEEN THAT COMING.

I MADE LARRY GIVE HIM TWO TICKETS TO THE BURN. I MEAN, HE SHOWED UP WITH HIS BOAT AND WAS COOL AND BELIEVED AND WANTED IT TO WORK. I MAILED THEM TO HIM, TO A PO BOX IN VALLEJO, AS I RECALL. AND I GOT BUSY WITH OTHER STUFF, AND, WELL...TIME DOES GO BY.

THAT WAS A HARD YEAR AT THE BURN, I REMEMBER. LOTS OF STRESS AND WORK AND CONFUSION. WE DID THE BEST WE CAN, BUT I REMEMBER WALKING DOWN THE ESPLANADE THAT DAY, THE SUN BEATING DOWN AND MY MIND FULL. I WAS KINDA STARTLED BY THE GUY BLOCKING MY PATH. ODD FELLOW, TO BE STANDING RIGHT IN FRONT OF ME LIKE THAT. I STOPPED WALKING, AND WAS TAKEN ABACK BY THE SIMPLE FACT THAT HE WAS NAKED EXCEPT FOR A POTATO SACK AND COVERED IN ASHES. HIS ONE HAND PUSHED DOWN ON MY SHOULDER AS HIS OTHER HAND PUT A SMALL THREE LEGGED WOODEN STOOL UNDER MY BUTT. HE KNEELED DOWN IN FRONT OF ME AND SAID, "I'VE BEEN LOOKING FOR YOU."

CAPT. RAY THEN PROCEEDED TO TAKE OFF MY BOOTS AND MY SOCKS. AND HE WASHED MY FEET.

HE TOLD ME THAT HIS WHOLE LIFE HE HAD BEEN SEARCHING FOR THIS PLACE AND THAT BECAUSE I WAS THE PERSON WHO BROUGHT HIM HERE, THE FAIRIES WERE GOING TO BE EXTRA MISCHIEVOUS WITH ME. HE TOLD ME THAT HE HAD RENEWED FAITH IN HUMANKIND BECAUSE OF THIS MAGICAL PLACE THAT WAS FREE OF PRUDENCE AND FULL OF VALOR. HIS WORDS STUCK IN MY HEAD. THEY CAME THROUGH HIS MOUTH WHICH WAS COVERED IN SOOT AND HE HAD BLACK SHIT SMEARED ON THIS TEETH. I'M GUESSING BUT I'M THINKING IT WAS SOME KIND OF EXERCISE IN HUMILITY. OR SOMETHING. THE LAST TIME HE CAME TO CAMP TIPSY HE BROUGHT HIS PICKUP TRUCK BED FULL OF OYSTERS AND SHUCKED THEM FOR EVERYONE ALL NIGHT LONG. TOLD FAIRY STORIES AROUND THE FIRE. PURE MAGIC.

Occupy

Occupy had an implicit constitution. It was never written down, there were no common documents or leadership structure or plan of any kind, but everybody understood it. And it was at the heart of what made that movement such a brilliant failure and an agonizing success.

Occupy's constitution was consensus. In everything. If you belonged to Occupy, no one would ever have any power over you in that sovereign space. And you would never have any power over anyone else. You would go together, into the world, into battle, to stop the most entrenched financial bureaucracy (kleptocracy)[†] in the history of the world, together. And nobody would be a hero. Nobody would take credit. Nobody would be more important than anybody else, and that's why you'd win.

Well, not win. They didn't win. The whole thing was a global Engineered Disperfection. That thing was a glorious failure. But they did something. They got the whole world's attention. They changed the conversation. They brought cities to a standstill. They were the spark that has ignited the inferno that is going to burn income inequality to the ground. They set the stage for the Basic Income argument. They made government look as weak as it is. Fragile even. Tell me that's not something.

Maybe you think their constitution sucked. Maybe it did. I'd never do it, I'd never try to get consensus out of thousands (millions?) of complete strangers. I don't even know how you'd do that. But just because their constitution sucked…well, they were still way more successful than any protest I've ever had. Except, I guess, that mine worked. When I protested a chain store gaming the system to open a store in the Mission, we got it shut down. When I protested the city privatizing parts of Dolores Park, we stopped it. I've got that going for me.

But I've never done ANYTHING even remotely approaching the scale of what Occupy did. Maybe it didn't work, but it was completely next level. Like nothing anybody had ever seen. And they did it because they all agreed to dedicate themselves to a constitution they had in common. And even though maybe it sucked, it made them—almost—unstoppable.

Imagine if that was just a trial run. If they all just tweaked their constitution a bit to make it even just a little better, so that they could—you know, issue statements, or demands—and then did it all again. That amount of people speaking with a unified voice? With a powerful message that was inarguable? That everyone would empathize with? Outside of nationalism and partisan politics?

Seriously. Imagine it. The world would stop until they got what they wanted. Maybe.

We could find out.

What are some of the privileges a constitution should offer?

There sure are a fuck ton of rules everywhere, so if we can flip rules into rights, we are definitely on to something. Even if this is just an intellectual exercise, it's worth doing. If we do flip rules into rights, things change. It changes a problem from an 'I-it' relationship between the management and the rule-breaker to an 'I-thou' relationship because the offender isn't just breaking a rule, they are infringing on your rights as a sovereign citizen of whatever event that has adopted this agreement. And when you start to calibrate your thinking to this, it's pretty much a total game changer. Let's look at a few rules that can be turned into rights, easily.

OK, say you have a rule that you can't put up advertising or marketing at your festival. Like, no banners for products or whatever. That can become a right for all citizens of the festival to not have to participate in the pollution of advertising. So if someone does it, they are infringing everyone else's rights.

Here is another one: You have the right to not be photographed. That was easy, right?

You have the right to open accounting about ticket sales of the event you are supporting. Or maybe the people of the event have the right to fairness in the selection of the content. That there would be a way to publicly present a grievance, if you felt like the event was nepotistic.

There are some festivals that could experiment with possessions. Maybe any/all food in the sovereign space can not be owned. Anyone has the right to any food. That would be ballsy. And fun. And weird. And possibly delicious.

Maybe silence is a right. Or the absence of digital communication.

People could have the right to Representational Democratic process and initiatives within the governing body of the event. Because when these events or festivals get big, they tend to become top-down organizations with the people at the reigns drunk with power, maddened by control and distrustful of anyone who could usurp that control. We see it happen all the time.

I think people would be receptive if you laid stuff out like this. They would be more inclined to get involved and contribute because it's not just a business. It's not some disingenuous word salad that is thrown together so an organization has a tab on their website you can click that talks about 'the vision' of the organization but then EVERY decision they make, *by pure coincidence*, gets more money, more attendance and more power. Just like every publicly-traded company on the stock exchange.

FIGMENT

David Koren runs a 25,000 person event on an island in a NYC park called FIGMENT. He wanted to have some kind of fun, governing, ethical document for his event, so he adopted the Ten Principles from Burning Man. He even added one: Gratitude. But he and his team re-wrote them and they are way better. Not as dark and broody. Check it out, flip back and forth between these and Larry's on page 79, see which ones you like better or maybe how you would word them, if you want:

Participation

Transformative change, whether in the individual or in society, can occur only through deeply personal participation. We achieve being through doing. Everyone is invited to work. Everyone is invited to play.

Decommodification

FIGMENT seeks to create social environments that are unmediated by commercial sponsorships, transactions, or advertising. We will not substitute consumption for experience.

Inclusion

Anyone may be a part of FIGMENT; no prerequisites exist for participation except willingness to work and play. We welcome and respect the stranger.

Self-Expression

Each individual and collaborating group has unique qualities, and through self-expression can offer a gift to others. In this spirit, the giver should respect the rights and liberties of others.

Self-Reliance

FIGMENT encourages the individual to discover, exercise and rely on his or her inner resources.

Giving

FIGMENT is devoted to acts of gift giving and volunteering. FIGMENT itself is a gift from volunteer artists and event staff, who hope that each participant brings an attitude of giving. Giving does not imply a return or an exchange for something of equal value.

Communal Effort

We seek to create an environment ripe for each individual to achieve personal artistic transformation — but the creation of such an environment can be done only through creative cooperation and collaboration.

Civic Responsibility

Each participant in FIGMENT is responsible for creating a civil environment for all other participants. We endeavor to produce this event in a way that fosters a civil society and that is socially responsible.

Leave No Trace

Taking everything with you and throwing it away is a great start, but it is only the beginning. We have to consider the long-term impact of everything we do, and continually find ways to decrease our impact on the natural environment.

Immediacy

Too often the limit for creative expression is the barrier between our inner selves and the selves that we present to the world. By breaking down that barrier, we can gain a profound appreciation for the opportunities that lie in each time and place.

Gratitude

We believe it is important to remind ourselves where we come from, and to appreciate what has been given to us to get us to where we are. We are not entitled to anything, and approach our relations to others from a place of gratitude for their efforts.

When I told David Koren about my thesis here and asked him if he would consider doing a constitution, he said, "Totally. Sounds fun." He and I don't know each other very well, but spent time chatting and laughing about how this would work and what would totally not work and an hour passed by quickly. His event, FIGMENT, has become a good idea that has spread to twelve other cities in the U.S. and a few other countries.

Clearwater Constitution

I once saw an event advertised where the promoter wanted to put the Ten Principles as a governing ethical guideline to the event. He just wrote on the flyer in parenthesis "Ten Principles apply." To me, it seemed weak. But really, what more could he have done? He is recommending a certain ethics that he wants to calibrate to. Right on. But wouldn't it be sexier if he wrote on the flyer: *"Clearwater Constitution will be in effect for the event"*. Because really, for him the Ten Principles ALWAYS apply, right? Right? Tell me I'm right because last I checked you can't change ethics depending on your geography. Or at least you shouldn't. Right?

I really feel like I'm doing a lot of the talking here...

A new document written by hippies

Something that every alternative social movement that tried to establish itself inside another country has faced is a basic problem: how can you really experiment with new governing models inside another government? If you're a socialist, and you want to create a socialist system, but you're in a capitalist country—what can you do? When is it treason to design a new system?

This is a pretty big problem. But it's one that artists don't have. Because we're just making our own rules for our own art groups. No threat, no treason—we're just creating additional rules and privileges. Maybe some day this will be a problem, but that means that this idea will have taken off and this would be a welcome problem. But right now we are just creating a world more like the one we want to live in, on a small scale.

Until a lot of us are doing it, at which point we get *somewhere*. Maybe not utopia, but maybe if you stood on a chair you could see utopia from there. Actually, maybe if Jimmy stood on the chair...It won't be because we overthrew a government. It'll be because we transformed the systems around us from mechanistic to organismic.

But it's important to understand: the constitutions should be written by the people who are living it. It's no good to do what the Chicago conference did with the world constitution. You can't write constitutions for other people's communities, only your own. It's like New Year's resolutions: you don't make them for other people. No matter how good they are, you don't do that. (Yeah, I'm talking to you, Tim Redmond.) You don't want to be the guy that does that. If your New Year's resolutions are so amazing, people will copy them. It'll happen. And if they don't, hopefully they still worked for you.

There's still a problem here, though. Maybe you've seen it: artists are shitty at writing constitutions. They really are. I'm living proof.

It doesn't matter. We start here. Reading this book of possibility is an alliance outside of borders. This book and the one before it are overflowing with other alliances. We keep making alliances and connections wherever we can in our lives and the world keeps getting smaller and smaller. Especially when those alliances are over where the current borders are. When the world is small enough, we won't need those borders.

Maybe somewhere two people are just going to form an alliance, write a constitution and invite the world to join them. And everyone will.

Don't say it can't happen. It totally can. It already has. Is there a good current example of a constitution that is actually 'by the people'? Yes there is, I'm glad you asked...

Iceland

Iceland is a small country. It could fit in your bedroom. You'd only have to host 330,000 people, give or take. (Some of them probably can't make it.) It's a place of dark winters and midnight suns. Their sagas and epic stories go back to the 9th century. They have a big tradition of landscape painting. They've got an active music scene, and a ton of museums for such a small country.

They're Pirates, building utopia

This far up-globe, the air is thinner. The water is a deeper, darker blue. Being this close to the moon also has some interesting quirks. Everyone here is left-handed. Their human disguises barely hide their Fey forms. Spritely slender fingers pruned by hot tubs push crackers of mashed fish past impossibly white teeth. Their long, wispy hair barely covers their pointy ears. Some trick of light. If you look at them in your peripheral vision, the fairy magic is easier to detect. You'll see a tail here, a wing there. The children are only made of light. They eat cucumber sandwiches and drink gin directly out of the juniper blossoms. Their fingerprints are poems. Iceland is a majestic place. The people of Iceland have a deference to the arts I've never seen before. They, reluctantly, identify as artists but only if you push them. Most of them. And they are prolific. I think they cheat and use their Fey powers when no one is looking.

The entire country uses Geothermal energy to keep the lights on. They don't need hot water heaters. This is one of the benefits of living on an active volcano. There is a lot of bathing. I imagine the public bathing places are steamy, and with wide smiles and eyes like oceans they hang their human forms on hooks and commune with the elemental forces of lava and water. They're blessed, these pixies. They've got the highest life expectancy, 10th GDP per capita, the least crime...they've got wealth/health/education. They're the world's third happiest country.

There isn't really a counterculture in Iceland. No graffiti. No bums. The elves have a ton of respect for other people, even their own misguided younglings. The First Lady is a fence for jewel thieves. Their church looks like a mausoleum for Loki, the God of fire and mischief. Every store here is a boutique. Everything is built in an odd, alien way. Almost temporary. I guess that's how you should do it when you have

to save vs. volcano once per hour. It's a strange place. The sharp winds hide a secret door to Avalon; this island is the capital city of the Moon and a tiny beach town with black sand at the same time. Their impossibly calisthenic Elven language is the only one I've not been able to learn to say 'thank you' in.

The people of Iceland have done four amazing things, politically:

1. Fired their government by banging on pots and pans

2. Nationalized two trillion dollars worth of debt

3. Wrote an open sourced constitution on Facebook

4. Jailed some of their banksters

Are you impressed? I'm impressed.

MY WIFE ACCUSES ME ON RARE OCCASIONS OF "EMBELLISHING", OR "PROPORTIONALIZING". THE WORD "HISTRIONICS" WAS USED ONCE. SHE ONCE ASKED ME TO DEFINE THE WORD *PREVARICATION*. I REMIND HER THAT I ONLY MAGNIFY WHAT IS ALREADY THERE. THUS, *SHOWING* PEOPLE SOMETHING. HAVING THEM PAUSE, AND TAKE NOTE. WHEN I GET IT RIGHT, IT'S GRACE. IF IT FALLS SHORT, IT'S ENTERTAINING. IF IT'S A SHITSHOW, IT'S JUST FUNNY. IT'S A GOOD BALANCE. IT'S RARE THAT A SHOW BOMBS SO BAD IT WAS NOT WORTH ATTENDING. BUT THAT RISK IS WHAT IT'S ALL ABOUT. DOING SOMETHING WITH NO ROADMAP. THE IMPETUS FOR A SHOW IS LIKE A CURSE. IT'S LIKE FALLING IN LOVE OR GETTING HIT OVER THE HEAD WITH A HAMMER. THEY USE THE SAME WORD FOR BOTH OF THESE THINGS: SMITE/SMITTEN. SAME SHIT/SHITTEN.

All the world's a stage

Svits madur. It means 'stage-man.' That's how the newspapers would identify Hordury Torfagson, the man who started the "pots and pans revolution." I mean, of course it was a Showman who did that. He got a bunch of people to go outside of their Parliament building and bang on bullshit. They brought a few thousand of their friends. The noise was deafening. You couldn't ignore it. You can't run a country when the people of your country are an angry mob outside the door banging on shit. The Prime Minister resigned. Elections were scheduled immediately. And the Pirate Party got three seats.

Now you may have never heard of the Pirate Party. I may have never heard of the Pirate Party until I started researching Iceland. Or maybe you already know, maybe you were way ahead of me on this. It's hard to tell, sometimes. Anyway, the Pirate Party is an independent political party with branches across Europe. It was founded

in 2005, and it believes in civil rights, direct democracy, anti-corruption, and a bunch of other stuff. (There's one in America too, where third parties don't count because we don't have a parliamentary system, that mostly exists to oppose the Digital Millennium Copyright Act. So people will have an easier time pirating music and movies. Hey—'pirating'—'Pirate Party'—get it?)

Iceland got screwed, absolutely screwed, by the 2008 financial collapse. They were a small nation, heavily invested in the financial industry—they were in much worse shape than we were. But somehow they not only got through it, they came out better off than they were going in, and even got some banksters in jail.

> ## "IT IS WELL ENOUGH THAT PEOPLE OF THE NATION DO NOT UNDERSTAND OUR BANKING AND MONETARY SYSTEM, FOR IF THEY DID, I BELIEVE THERE WOULD BE A REVOLUTION BEFORE TOMORROW MORNING."
>
> ## —HENRY FORD, 1929[t]

That's because they had the Pirate Party, which has become a solution to all the cronyism and billionaire bullshit that has been happening there. I went to Iceland, to meet a few of them. See what's happening there on the ground. Because it's totally blacked out in mainstream media. The pixies are angry, for sure. But also well educated and decisive. And they live in a culture of art and innovation. They have done the impossible. They are on the precipice of an actual revolution with zero blood or money loss.

It hasn't been easy. Or straightforward. It's been a struggle, a see-saw. It's been back and forth, winning and losing and trying again:

YES! They created a constitutional congress that wrote a great document pretty much open source using Facebook! Are you listening to me? THEY WROTE AN OPEN-SOURCE CONSTITUTION, ON FACEBOOK, FOR THEIR WHOLE COUNTRY! Tell me that isn't amazing! Tell me that doesn't give you pause!

NO! There was a rules violation that resulted in a lawsuit!

YES! The constitution was put on a special election and the vote was 67% yes!

NO! The right-leaning government refused to put it up for vote in Parliament so it was never ratified!

YES! The Pirates are now leading the polls in Iceland!

Back and forth the tennis ball goes...but they have gained so much ground now. As of this book going to print, the Pirates are polling at 28%, more than four points

ahead of the next polling party. They're on track for a parliamentary majority—and if they get it, it means that the world's first open-sourced constitution will be implemented, finally. It won't be the last one!

But let's talk not about what they did. It's great, but you can go read Wikipedia just like I am now in another window. We are here to talk about *how* they did it. And how they knew they could. Here is what I see as a list of factors:

- Stageman is a show promoter. He got people to go to his revolution. They had art.

- The leader of the Pirate Party, Britta, is a poet. A really good poet. More art.

- Because they are an artistic culture (do you see a theme here?) they are familiar with building things themselves, with having imaginative ideas and working to make them real instead of waiting for other people to do it.

- They are educated.

- They have the highest percentage of cell phones per capita. These are people who talk with each other.

- They are happy. People who are unhappy don't get mad effectively: they get resentful and bitter and jealous and they go through a mitosis so much faster. But people who are happy... don't piss them off. They're less likely to get mad, but when they do, they will be the most effective enemies you've ever had.

- Their cultural institutions are relatively new. Their arts (and money) came after WWII. So a lot of the social interests aren't as entrenched.

- They collaborate easily with each other: Iceland is the least mechanistic place I've ever seen.

People predicted it would happen sometime. Marx predicted late-stage capitalism would begin to crumble under self-interest and corruption and alienation...sound familiar? But nobody predicted it would happen like this. Everybody thought political problems would need to have political solutions. So they tried communism, and they tried fascism, and then some of them tried communism again, and capitalism kept chugging along, getting more and more efficient which improved a lot of things but also created even more self-interest and corruption and alienation...it took us a long time to realize that political problems would have artistic solutions.

But here we are.

Iceland is a perfect testing ground for putting all these pieces together. First of all, it's tiny. They are affluent and isolated, so it's easy to measure what is working and what isn't. They are educated, so you aren't going to get some demagogue coming to power by using scare tactics and phony fear. And finally, their affiliation to the arts makes them a perfect crucible for innovation and experimentation.

And so, pixies who speak like cartoon elves are ushering in a new Renaissance of art and innovation, and about to ratify the most liberal constitution ever implemented. They're pirates, building utopia. What can be better than that?

But there is a fly in the ointment, and it's pretty major. The Icelandic people detest politics.

"What?" you might be saying. It's true. The fundamental similarity I found in EVERYONE I met in Iceland is that they want to have nothing to do with the political process, they don't want to talk about it and they don't care what you think of them AT ALL. Even the Pirates I talked to were totally burned out. It was like that synchronized eye rolling we are all so familiar with. It's a combination of cynicism, feeling like it's beneath them, and a dash of 'someone else will do it.' It was totally confusing and totally alarming. With all their education and magic powers, all their money and all their art and culture of collaboration, for all that they're perfectly set-up to influence a new understanding to spill onto a world stage: they don't care. Maybe it's because they live on a remote volcanic island on the Moon? Or maybe it's because that is the nature of civilized culture? Any people who get good enough are going to disdain politics? Maybe it's true: Art brings people together, politics divide people. Whatever the case, the Fey creatures of that Nordic lava rock wish no ill on the rest of the world, but are totally disinterested in the affairs of the other 6,986,676,998 of them. You remember The Guy? They don't want to be The Guy. The don't even want to invite The Guy over for coffee.

It kills me—it KILLS me—that I have finally found a whole culture on the cusp of proving my thesis of art and constitutions and utopia…and they don't give a shit. They don't. They just don't care. It's like somebody set up a special Engineered Disperfection, just for me. If my whole philosophy weren't that you have to orient to failure, I would be incredibly depressed. I would have Kafka quotes tattooed on my arm and chain-smoke in the corner of my wife's coffee shop.

Maybe Iceland will pass their constitution, make history, change the world, and usher in a new era of utopia, in spite of themselves. Or maybe they'll just go see an opera by a local musician based on an ancient Norse saga. Could go either way. It's up to them.

But we don't have to wait on them. The whole point is, nobody else has to be The Guy. You can be The Guy. Your friends can be The Guy. Every artist you know can be one of 'The Guys.' Iceland's whole constitutional revolution began with a stage man banging pots and pans. You can do that. Anyone can.

I PROMISED YOU I WAS GOING TO SHOW YOU PATTERNS AND SYSTEMS THAT I HAVE BEEN STANDING IN FRONT OF MY WHOLE LIFE. AND I HAVE, TO THE BEST OF MY ABILITY AS A WRITER/ THINKER. THIS BOOK WAS AN ADVENTURE TO WRITE, AND GOING TO ICELAND WAS PART OF THAT ADVENTURE. OK, THIS IS WHEN I'M POURING THE BOILING OIL OVER THE SIDE OF MY GENOESE TOWER ON YOU. I'M DEFENDING MY TOWER! I MEAN MY THESIS! YOU MAY BE ABLE TO SHOOT A THOUSAND HOLES IN SOME (OR ALL) OF WHAT I'VE SAID HERE. BUT I HAVE PROTECTION! EASY. I'M PROTECTED BY THE FACT THAT THIS THESIS IS AN INTELLECTUAL EXERCISE AND IN ITSELF IS AN ENGINEERED DISPERFECTION. I OFFER IT AS A GIFT. IN THINKING ABOUT ALL THIS STUFF NIGHT AND DAY AND IN AND OUT OF WEEKS AND ALMOST OVER 30 YEARS I HAVE USED UP A LOT OF MY LIFE TO UNDERSTAND *DUENDE* AND HOW TO SEE THE MECHANISMS I WISH TO AVOID IN THE SYSTEMS THAT ARE FOREVER TRYING TO SUCK THE MAGIC OUT OF US. HAD I NOT BEEN BEWITCHED BY THAT SORCERY, I WOULD HAVE NOT BEEN ABLE TO DO ANY OF THAT STUPID SHIT IN THE FIRST BOOK, NOR WOULD I HAVE BEEN ABLE TO WRITE THE FINAL CHAPTER IN THIS ONE.

Fallen Cosmos

Treasure, part I

There was $523 worth of crumpled one dollar bills in the musty old steamer trunk. Only five of the thousand people in the room had keys to any particular trunk, of which there were ten trunks total. Some were out in the open, some were quite hidden. But the awe on our faces when we counted the money was memorable. One of the organizers was sure it would be gone. Another said it would be half gone. I knew better. Because when you architect an experience outside of commerce, actual foldable money is nothing more than a prop. But that the amount of extra money in the trunk was the magical number 23 was just sublime. We put $500 in the trunk before the show. Did some people take and some people give? Everyone give? Did only one person open the trunk? We'd never know...

When it was unlocked and the top was lifted, the calligraphy on the inside lid read the following note:

> *"You came into this world pure. Money is but a perversion. It is up*
> *to you whether you want to indulge or rid yourself of it."*

One of the other trunks had champagne and caviar. One had fancy coffee and chocolates. One had slips of paper with poems. One was porn and lube and toys. Each trunk a different decadence. Absinthe. A true mirror. Flowers. You got the key to the trunk weeks before the event, by following clues to secret places where you would meet strange characters who would have you perform exercises of philosophical significance to challenge the metric of reality. Of course, once we have taken them this far, we can't just give the address to the venue away...oh no. In order to get to the Fallen Cosmos, you must follow the *Ethereal Path*. A scavenger hunt based on the very ore of the human condition. For people who showed an exceptional willingness to mine this ore, they were given the means to open the trunks that contained mysterious treasure. We put the keys in a bag and mixed them all up, so we didn't know who got a key to which trunk. It was a secret, magical event inside the other event and it was all of our favorite part.

It's possible that I'm getting ahead of myself here. I guess I should start at the beginning...

It had to be some kind of record. The entire description was 51 words:

> *The Fallen Cosmos will manifest in San Francisco, the city of Art and Innovation, on Saturday, January 31st 2015. You bestow this experience as a gift. The only way to guarantee someone the opportunity to visit the Fallen Cosmos is by giving them one of the rewards listed on this page.*

The 1:26 second video of outtakes of a paid actress losing patience and arguing with me off camera about why she couldn't give the viewer any information on the show was amusing. It had to be the least informative Kickstarter campaign in history. The only reward was a ticket to the event, with a $50 price tag. With a funding goal of $32,000 it seemed comically impossible. Little did everyone know that this was just the beginning...

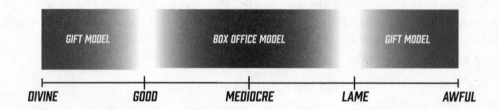

Would you have paid in? Spent some money to give this experience—whatever it was—to someone you knew? Knowing what you know about me? And the people I was working with?

How do you think it shook out?

Take a moment. Give it some thought. Because you are now in exactly the same situation that everyone looking at the Kickstarter was. We were being very up front about this.

Our charter was as follows:

· We are creating an experience.

· No one will know anything about it until they experience it.

- The only way to experience it is to be given a ticket **as a gift.** You cannot buy this experience, it has to be a gift. So everyone there will have gotten in for free, because someone cared about them or thought this was an experience they should have.

What would you do? What would other people do?

Take another second, and then I'll tell you.

You thought it through? Figured it out? Okay, here's what happened:

We shut the Kickstarter down after getting over $40,000 in donations—almost $8,000 more than we asked for—because if we gave away any more tickets we'd have been over capacity.

If that's not amazing, I give up. Over 700 people had bought people they cared about tickets to the mysterious event: The Fallen Cosmos.

This is a very good beginning to a story.

But before I tell you any more about it, let's talk a little about what just happened here—about why we would go through all the trouble of re-inventing the thing that *never* changes in *any* show, the ticketing, to create a event in which admission could only be given away, not bought for yourself. Why would we do that? Why would we create a governing structure that would make it harder for people to come to the experience we were curating for them? Why write a constitution that required that that people appoint *other people* as citizens?

To explain it, let me tell you about the *Night Heron*.

The Night Heron

I was visiting NYC and my friend Tod Seelie[12] wanted to meet for a drink. He said he had something he wanted to give me. We met. We drank. At the end of our time together, he gave me a pocket watch with a phone number inscribed on the inside.

"What's this?" I said. "You going Steampunk on me?"

He told me to call the number, and do whatever it said. So I did. The voice on the other end of the phone told me to stand on the corner of 23rd Street and 6th Ave in front of Gray's Papaya on Friday night at 11:00 pm. And hung up.

To be honest, I almost forgot. NYC is home for me, and that day was just a weird day. I was staying in an apartment in the West Village and was just flooded with emotion.

12 The most excellent photographer who took half the pictures of the boats in the *Book of the Is*

I used to own a little moving company, and I always wanted to live in one of those apartments in Greenwich Village and know everyone on my block and go see jazz at the little cafés and sit on my stoop and chainsmoke. The Greenwich Village of my youth was mostly gone, and it left a hollow feeling in me. You truly can never go back. After being gone 21 years, I had exactly two phone numbers of people I still knew. It was kinda devastating. I mean, I knew *everybody*. Now I'm a tourist. I didn't know where to go. I didn't have the inside track on the art and culture that was changing the world like I did back in the day. It wasn't a good feeling. I was on Bleeker street feeling sorry for myself and I went to pay for my drink and felt the pocket watch in my pants. "Shit!", it was like 10:50. I dashed to a cab and made my way to 23rd street.

The pay phone rang exactly at 11:00pm. The first thing I thought was I couldn't remember the last time I actually used a public pay phone. I was expecting a group of people or something. I was expecting to see Tod. It was raining. The voice on the other end of the phone told me to walk down 23rd street to the middle of the block and there would be a red door. To knock on it 3 times. And hung up. I walked, knocked and the guy who answered the door seemed like one of the bad guys from the Matrix. The ear thing and all. He asked me if I was a cop. I told him that I was more of a criminal. He let me in, took my watch and led me and 4 other people up 20 flights of the worst stairs I'd seen since my days of being a squatter. The building was totally falling down, totally abandoned. By the time we got to the top, I was thinking "this better be good." I was winded and was not looking forward to the downward climb. When we got to the roof, the rain was really coming down. The Matrix guy escorted me to a 30' extension ladder. The other end of which was going into a rickety old wooden water storage tower, through the bottom. It was sketchy. I ascended, but didn't like it. I was totally wearing the wrong shit for this. Wing tips and a suit with a cashmere coat. Remember half hour ago I was at a pity party for myself on Bleeker Street, lamenting that when I lived here in the 80's, I tuned Elliot Sharps' guitars and saw Karen Finley shoving yams up her ass at an illegal club in the meat-packing district.

NOTHING could have prepared me for what happened when my head poked through the floor of that water tower. It was a 1930's speak easy piano bar. Beautifully decorated. With a jazz band. Little tables. Fancy cocktails being drunk by fancy girls in cocktail dresses. How did they get an upright bass in here? Was there a piano? I can't even remember I was so overwhelmed. I ended up talking to someone there about Hegel and the logic of art and philosophy. The rain poured outside, the drinks poured inside and for a few hours we were safe from the machines. At the end of the night, the proprietor sat down at my table and said, "Can I ask you a question?" I nodded my head. "Do you want to buy a watch?" With effusive wonderment, I gave that fucker every dollar in my pocket.

What would that experience have been like if, instead of being given a watch and instructions and going in with my mind empty and my eyes wide, my friend Tod had told me "Hey, there's a really cool jazz café hidden in a water tower. Do you want to go? You can buy a ticket for $30?"

Maybe I would have said, "Sure, that sounds like a pretty cool thing," or maybe I would have said, "Nah, I'm kinda tired and depressed tonight." And if I had said yes, and bought my ticket, I would have known what I was getting into and had expectations about what I wanted to see and I would have thought things like, "Fuck, why are they making us walk up stairs?" And by the time I got to the amazing thing they did, I would have already felt kind of blasé about it.

But the fact that I didn't know anything about what was happening, the fact that this was a gift my friend had given me personally, the fact that this was an experience that even though somebody's money had traded hands somewhere along the line, was happening outside of commerce for me...the fact that I was entering a whole different space where a whole different set of rules applied that took me out of a consumerist mind-set...meant that I couldn't have been blasé if I tried. My mind was blown.

I adopted that idea for our Fallen Cosmos show, and expanded it. The Night Heron was a small operation, comparatively. For our event, we went all the way in the other direction. But as soon as I saw what they'd done, *really* created a space outside of commerce in which an art environment was entirely experienced as a gift, I knew I was going to steal that and take it to the next level.

Miss Information

Designing our event with this peculiar ticket mechanic also solved certain other problems. By Kickstarting our funding in advance, and distributing all our tickets this way, we didn't have to do any marketing for the show. We eliminated any expectations, yes but we also didn't have to make a flyer, we didn't have to beg people, "Hey, you'll be there, right?" or put lousy ads in the paper. Whether or not people actually came, our event was funded. And we had no doubt—no doubt at all—that people were going to come. We could focus on the content.

But it also created problems. And I'm not just talking about the month-long headaches involved in getting everybody who bought a ticket to identify the person they wanted to give it to, and then reaching out to the gift recipients and informing them that they had a ticket to this experience, and making sure they could go, and getting back to the gift-giver if their recipient said, "Oh, sorry, I'm getting married that weekend, I'll be out of town" or something, and checking to make sure people

really weren't giving themselves a ticket...we worked up a whole dynamic info graphic showing who gave tickets to whom. It's beautiful. Constellations of data. The Gift of the Magi, written in the stars. We called it the "Gifting Graphic." It's on the cover of this book you are reading. You can clearly see the three distinct, colored lines (each Fallen Cosmos show) and every 'star' is a person. You are literally seeing the lineage of the tickets going from one person to the next. In all, only six people out of more than 700 tried to cheat. That was impressive.

But yeah, back to the big problem: we were undertaking a massive event. By the time we were done, it would involve over 400 artists and volunteers in over 100,000 square feet of space. And we wanted to keep everything about it a secret. Have you ever tried to keep a secret with over 400 volunteers, many of whom are friends with some of the people you're trying to keep the secret from?

We worked very hard to try to keep everything under wraps. We wrote up a humorous non-disclosure agreement that people had to sign before they volunteered, complete with an oath they had to take before being told anything. We had secret meetings. We used peer pressure. We provided snacks.

But we knew it wasn't going to be enough. Of course somebody was going to talk to somebody. So we didn't wait around for that to happen and get defensive when people told their friends something about what they'd been working on for the last six months.

Instead we created a massive *dis*-information campaign about our own event.

We created a dress code that had nothing to do with the actual content of the event. Why? Because people who try to figure it out, that's why. We created a whole mythology about an ancient global conspiracy that had been controlling laws and evolution and governments, and revealed inconsistent pieces of it, one at a time, in drips and drabs, to people with tickets—and it had nothing (well, almost nothing) to do with the actual event.

We didn't create a website to market our event—we created a website to lie about our event. We didn't create videos to get people to come, we created videos to keep people who were coming confused about what to expect. We ran a series of blog posts unveiling the secret occult symbols in tech company logos, and said it was really important to understanding what we were doing. We created a special series of scavengers hunts called *The Ethereal Path* that people could get information about on text messages sent from 'people'; involved in the mythology and get some fun prizes, including some mysterious keys to unlock secret treasure...

People loved it. They ate it up. They demanded more. And you might think (I'm gonna skip ahead a little here) that people would be angry with us, or at least upset,

when they eventually found out that all of this lead-up—months and months of lead-up—was total, utter bullshit. That they'd demand their money back or something.

Boom. Gotcha. They didn't pay any money, first of all. Remember that.

You've always got to remember that. It makes such a huge difference.

But even forgetting that, no. That never happened. They never complained. Not one person! Just the opposite! Because this wasn't required reading or anything, this wasn't homework they had to do. This was really interesting stuff, by talented artists, that we were giving them to think about, and to engage with. This was a dramatic story, well told, that they could follow along with, interact with, go hunting for clues with, design costumes around… they were engaging with the story we were telling, knowing it was leading up to something very big down the road, and the one thing they never had to do was spend a cent. They were not consumers. At all.

And when people start interacting with art in a way that goes beyond consumerism and entertainment, you know what that means they're part of, right?

Instead of being angry, people came up to us after the event and thanked us for it. Wanted to meet the guy who made the videos, find out how the text-message scavenger hunt worked, talked about using all the history we put into the mythology as a way of talking with their kids about ancient cultures and religions.

And they loved—just crazy loved loved loved—the fact that the disinformation campaign worked. That they actually really and truly went to an event this big, this anticipated, without having ANY idea what it was about or what was going to happen. When the people came to the event, they truly had no idea what was in store for them. Many people told me that they couldn't think of another time in their life when they Didn't Know as much as they Didn't Know this time.

Managing abundance

In the meantime, our ticketing mechanic created an even greater sense of scarcity. We'd gotten $40,000 giving tickets to almost 800 people, and we were getting requests daily from people asking, "Can't I have one? Can I get one for my friend? My wife?" It had been an egalitarian event at the start—anybody could go to the Kickstarter. I would tell them, "Money isn't a useful tool here in this world we have created." There wasn't a secret password or a club you had to belong to. But now it was ridiculously exclusive. The people who were going were so excited that the people who heard about it were all but storming our ramparts.

"Elitists!!!" The accusations flew. "I don't want to go to your exclusive rich person party anyway!" a dear friend yelled at me over Facebook. People were mad. "What do you mean there aren't any tickets available?" The misinformation campaign worked all too well. No one knew what it was, and it was driving them crazy. We tried to accommodate as best we could. If people who had been given tickets didn't respond, and the person who had given the ticket couldn't think of anyone else to give it to, then we gave the spare tickets away through an essay contest we set up. People told us (sometimes in moving, sometimes in hilarious ways) why they thought they should go, and we gave tickets to anyone who bothered to try. *Anyone* who wrote an essay got a ticket. Ha! Again, nobody was buying anything. Well, almost anyone...

One person did get over the walls of our rampart. Because we honestly never thought demand would get this crazy.

We used Eventbrite to manage our tickets, and the way the Eventbrite software is set up, the tools get restricted once there are no tickets for sale. You have to have at least one ticket for sale, or it triggers a function that we didn't want triggered. So we put up one single ticket, the Pie ticket. AND DIDN'T ADVERTISE IT WAS THERE. And put it for sale for $3,141.59. Because, come on, who's going to spend over $3,000 on a ticket that you get for free if somebody who likes you spends $50?

Yeah well...

A few days before the event, Arnold calls and is freaking out. "We can't use Eventbrite! The functions are disabled!" Holy shit. Someone bought the $3,141.59 ticket. They wanted to go that bad.

We couldn't believe it. We thought it was a prank. Finally, when it was obvious the money had, in fact, gone into our accounts, we checked it out. We were pretty sure we were going to insist that we give the money back and void the ticket, because THIS IS NOT AN EVENT YOU CAN BUY YOUR WAY INTO! But, whadd'ya know, it was a company that wanted to give the ticket as a gift to a customer. A gift! So, after a four-hour meeting re-evaluating what we were doing and how Chaos works...we let it through.

Treasure, part II

At the second Fallen Cosmos show, the trunk with the $500 had a very, very different encounter. Same trunk, same amount of money ($523). Very different outcome. Anyone could guess what happened, really just by being in the space. But I actually saw it. And it was beautiful. As I said before, when cash becomes a prop, shit gets funny.

The first time I used cash as a prop was at the 'Losers Ball,' the election night party

when I ran for mayor. There was like $1,500 or so left in my mayor bank account that I didn't spend on portable toilets put on the street in the Castro for Halloween with big posters on them that said, "Chicken John wants your #2!"[13] I used donated money as confetti.

The second time was during the show Agents of Chaos, the un-*author*-ized book release party the SFIOP threw for Johnny's Cacophony book where I gave Jamie DeWolf a tall laundry basket full of $800 in ones to give to people as prizes for coming on stage and competing in contests that he was basically making up on the spot, "Who can sing a really high fuckin' note?" He would then jam the microphone at them and then the next person and the next, giving the best one a few handfuls of the stuff. "I want a man wearing woman's underwear on the stage RIGHT NOW!!!!!" There was such a man who didn't mind dropping trou for all assembled at the Castro Theatre that night. Handfuls of dollars, half of which were spilling on the floor and a guy with a push broom sweeping them off the stage. "Who has the worst tattoo?" Easy pickin's there. "I want to see mass nudity of this stage!!!" Jamie's call to arms filled the stage with naked people holding clumped bundles of clothes they were wearing just a moment ago. And it was exceptionally funny because no one had anywhere to put the wad of cash he was handing to them. The guy is a master of Chaos.

At the end of the second night of the Fallen Cosmos, the trunk had $63 in it. I knew why. I saw the guy who took the money out of the trunk. The guy was a soft looking fellow. He was wearing a tux shirt, as I recall. $460 or so of the $523 that was in the trunk he shoved in his shirt. Which was well within the agency we afforded him. He shoved the money in his shirt and was walking around the Earth section of Fallen Cosmos in gleeful delight grabbing clumps of cash and throwing it in the air above people's head and squealing, "Money!" in falsetto. With grin on his face that I'm used to seeing on toddlers.

So, what *WAS* it?

What did they find at the end of the rainbow? After we were through milking (and milking and milking) the infinite possibility that 'ANYTHING CAN HAPPEN WHEN YOU SHOW UP!' they eventually had to show up, and then Anything had to become Something.

So what did we do?

The first thing you have to understand is, the part that I've told you about so far, from the Kickstarter in October to the show at the end of January, those four months, were just a sixth of the total time this event, The Fallen Cosmos, took to put together.

13 I was running for second place, get it? I want your #2? Because #2 means...oh, never mind...

The whole thing actually took two years from the time we conceived of the spark of the germ of the egg of the idea, to the big 'everybody's here, now what the fuck happens' moment.

A lot had to happen over those two years to make this work. First, we founded a non-profit dedicated to doing art like this: The San Francisco Institute of Possibility. A non-profit can bring people all across our community together on a grander scale than anything we could do on our own. And along the way we produced some more fun events, all detailed on our site if you are interested: www.sfiop.org.[14]

The other really hard thing we had to do was find a space. Big enough for the idea to fit. That we could afford. To use for weeks of build time. In San Francisco. The most overheated real estate market in the country.

Yeah, that took two years. You could not, literally could not, go to a real estate agent and say, "Here's what I'm looking for." It would have cost us millions of dollars, and probably been sold out from under us for condos. You had to know a guy who knew a guy who owed a guy a favor…it was a whole adventure unto itself.

But so you know: a lot had gone into this before the world's least informative Kickstarter was ever displayed.

Magic moments on a mass scale take **work**, is what I'm saying. And it wouldn't have been possible without an organization. Or an idea. Now we had both. The idea was to turn Hieronymus Bosch's iconic painting *The Garden of Earthly Delights* into an interactive environment that you can explore. We set it up so that you, literally, go IN the painting. And spend 2½ hours interacting with the characters, heroes and villains that Bosch created 500 years ago. We did a call to artists, and would have meetings we would lay it all out. The ticket mechanic, the show, the scale, the narrative… people thought we were out of our fucking minds.

Finally, something good came out of going to Art School!

People who go to art school have to write interpretations of works of art. Like paintings. There are thousands of interpretations of that Bosch painting on the internet. We needed to find one that we could use as a script. The work is so crazy and so complex, there is no way that hundreds of artists could produce work using it as a resource without some boundary or restriction. We needed a director, but not like some dickhead control freak telling people what to do. We needed a written interpretation that people could refer to. But one that was funny, not too serious. Not some 'art-speak' pseudo-intellectual word salad that doesn't actually mean anything.

14 We even made a 'kit' of the Fallen Cosmos. So if your art group wants to do it, or steal any of the ideas, we've made it very easy: www.sfiop.org/kits/FallenCosmos

Arnold found just the thing: Lee van Laer's *Esoteric Analysis.*† Van Laer did something that none of the other interpretations that I saw did: he turned the beings in the painting into characters. With motivations and history and feelings. He imagined the world that Bosch painted, he gave it a directive and in doing so, a story. And unlike any interpretation of the work, it now had an ending. Which is exactly what I needed for my show. So a man we have never met from Sparkill, NY, who might be slightly crazy, directed our event from a slide show he made in 1996. Sparkill is on the Hudson River, around the Tappan Zee bridge. I wonder if he came down to the docks to see our junkboat show when we stopped there in 2008?

The call to artists we did rustled people from all disciplines. We made them all watch the one hour slideshow Lee van Laer made, then they basically did whatever they wanted for the show with little direction or management. We started allocating space in the 100,000 square foot venue for the artists do their things. Every time I went there, it got smaller and smaller. In a site meeting once, I actually said it, "Fuck me, we need a bigger space..."

The painting is a triptych, which means it's kinda a mechanical box that opens like a flower. Originally, this work probably hung in a church, and when the commoners came on Sundays, the work was closed. Only for special functions or when the nobles were there was it opened. That's the way it was in the 15th century. The painting was a commission from a wealthy family, likely, and sacked as a spoil of some war hundreds of years ago finding its home in Spain, at the Prado. I learned this and everything else about Bosch at the first show of his work at the Noordbrabants Museum in Amsterdam celebrating his life and work in early 2016, the 500th anniversary of his death. His work—painting, sketches, things from bibles and even the letters the wrote and the endless books available for purchase—shows a common theme of a mind that believed in magic. His work and the work of his apprentices is wholly other, and are often attributed to ushering in the dawning of Abstractism, Realism, Impressionism...all of it. He also worked with color palettes that no one had before and pushed every line and limit he could. People spend their whole lives devouring his work and arguing its meaning. Their whole lives. Like maniacs.

With Lee van Laer as our director, hundreds of artists, mechanics, builders, makers, costumers, Balinese musicians, painters, dancers, video artists, a 50-person choir, fencers, card sharps, mad scientist Tesla coil maniacs, flower arrangers (!), actors, curators, helper monkeys, perverse Rococo gormandizers, remote control guys, role players and an entire door/security staff of monks provided the core structure of the Fallen Cosmos. Then we opened the doors to 700–800 people ALL in costume dressed to the nines. There was *no way* to tell who was in the show and who was the audience because in that magic environment imbued with that much fairy dust there wasn't any difference. No difference at all. The air was ozone. Time flowed like syrup. *"The duende is strong in this one..."*

The show goes on!!!

All right, so, the big night is coming. The week of, we finally announce to people that the location will indeed be in San Francisco, and what the transit and parking options are, so that they can plan their trips. The day of, they get the actual location. A long dormant pier on the waterfront. They are also given different times to arrive: other people may be going in at 7, and 7:30, and 7:45, and 8, but you're with the group that's going in at 7:15. *Got it?*

You show up a little early. You see the warehouse in the distance. It's close off, but there are weird lights coming from inside. You see that there's a courtyard filled with hundreds of people in wild and extravagant costumes—some in perfect harmony with our strict dress code, some deliberately flaunting it. These are your fellow attendees. You hear strange, sacred music booming out from near the closed-off entrance to the warehouse. Docents in a variety of monk and nun-like costumes work their way through the crowd, checking people's tickets.

This was interesting, by the way, because in 100% of every other show on earth, people at the door are checking tickets to try and make sure you are the person who actually bought the tickets. At the Fallen Cosmos, we were checking to make sure that the person holding the ticket was NOT the person who had paid for it. Kinda neat. And a lot more fun. But anyway...

The docent monks and nuns gave everyone a small sealable yellow envelope, and asked them to power down their phones and gizmos and e-tethers and put them inside the pouch and seal it for the rest of the show. We didn't take them (what a logistical nightmare shitshow that would have been), we created a little ritual that set a clear expectation: if you get your device out, you are very literally breaking a seal. And everybody else, who has gone through the exact same ritual and has been good about keeping this trust, will know what you've done if they see you peeking at your Facecrack. At the end of the night, we found ZERO yellow envelopes on the floor. Zero.

You saw a group, maybe two, go in ahead of you. The warehouse doors opened, whatever was inside was dark, the docents herded everyone with the right ticket time through, and then the doors closed again. You heard talking, maybe shouting, from inside, but it was hard to tell over the weird sacred choral music from a culture you probably couldn't even identify.

Finally it was your turn.

Your group walked in to discover that inside the warehouse was...an art gallery. A dimly-lit art gallery, stretching out into the darkness, with white lines on the floor and **The Docent** (the actress/governess from the Kickstarter video, if you were *really* paying attention) to lead you through it.

The doors closed.

The Docent welcomed everyone to the Museum of Transcendent Art, in annoyed tones, wielding a pointer stick. She then explains that there are some rules—like always stay within the white lines, and no talking. One guy (**The Trickster**) inevitably gets out a cigarette. She tells him no smoking. She leads everyone around from painting to painting, all of the great works of the world from Dali to Van Gogh, describing their history. **The Trickster** and **The Docent** keep finding themselves at odds. Maybe you know something about art, and notice that the explanations are all bullshit. Maybe you don't.

Eventually she tells you that we're coming to the crown jewel of the collection: Hieronymus Bosch's *Garden of Earthly Delights* triptych. This, she tells you, is gonna you their socks off. Except she never says "knock your socks off" because she's not that kinda girl. Very prim. Schoolmarmish. And **The Trickster** has flustered her. Anyway, the moment is coming. But first, to make sure you really appreciate what we're looking at, she's going to show you a short film about the Garden of Earthy Delights. If you'll all just follow her over here …the movie will be shown against that wall. So maybe sit down on the floor. Get comfortable.

At this point **The Trickster** asks, "How long is the film going to be?" Because, remember, this is your Saturday night. You didn't know what you were getting into, but you really never thought it would be an art history lesson. But it's been 10, 15, minutes now, and that's all you've gotten. Is this what's really happening? All that hype? All the costumes?

"Don't worry," **The Docent** explains, "The film is just over an hour. Plenty of time to see the other work in the gallery."

"An HOUR?" **The Trickster** shouts back. "Can I at least go to the bar?"

"No," she replies. "The bar is closed until after the showing."

"Fuck this," he says, he's out. He storms off.

Everybody else, though, sits down. Gets comfortable on the floor. The movie starts. The curator walks away. Apparently this is really happening. Panels of the painting *The Garden of Earthly Delights* are now projected on the wall as a narrator talks about the historical time Bosch lived in.

This is really happening.

Then the film freezes on a full shot of the triptych, which is projected up against the wall. **The Trickster** walks onto the frame! He's inside the movie!

He tells you he got *in* the painting. He starts talking about the amazing, incredible, unbelievable, stuff that is happening in there. He tells you you've got to see it! You can hear the faint sounds of a choir, but you can't tell where it's coming from. He tells you that you have to make a choice, do you want to live your life in the gallery or do you want to be in the painting?

Now, the truth is, we thought the crowds were going to be pretty hesitant about this. Not have any idea what to do next. Need a lot more exhorting. We had a plan B if they didn't 'get it.' We didn't need it. There were a total of twelve 'groups' that came through the gallery (the opening was only so big). Every group figured it out instantly. They were so excited when they figured it out. People were just fucking running as fast as they could with their heads down busting through the wall. Brutal, mob-like animals. Twenty minutes in the gallery environment had turned them feral.

The choir beckons you through the wall into a garden of flower and plants. You are surrounded, in this new environment, by a built-up interactive replica of the first panel of the Bosch painting. The 'Eden' panel of *The Garden of Earthly Delights*. Now you get to wander around in it. Explore it. But any time anybody tries to talk, to say anything, to use language of any kind, one of the strange animal beings wandering around the landscape shushes them. There is no language here.

Once everyone is inside, a new wall is put up behind you, the doors to the museum open, and everything starts again. You can hear **The Docent** spouting about Starry Night...

Picture all that for a second. Just imagine it.

Right? RIGHT!

Okay, so, eventually everybody is inside the Garden of Eden section of the painting, and has had some time to look around at the strange reactive plants and the odd egg-shaped buildings, and to interact with the weird animals and Shhhhh! No talking. The shhhushers shush. Shut it. Strange foods on platters passed around, odd videos playing in odd, alien cabinets, curious glowing plants and a carousel of alien animals are just part of the queer fun of this Eden. You can also welcome new guests from the gallery. Shhhhh! Shhhush. There is no language in Eden. In hushed whispers, "language is a corruption...."

Four groups come through the gallery into Eden. It's packed. Too full. There is more room, over there, but that part of the place is not lit and is guarded by bizarre animals that shake their heads, "No" when you try to walk past into the darkness. It's uncomfortably packed. People are starting to talk. The music that was angelic and quiet is louder now and distorted a little. The strange animals are spooked. Some of the angelic, solar creatures are making out...then the soundscape changes, and

a new section of lights come up...to reveal a whole new panel of the painting. The Earth section. There's a whole new landscape to explore, new creatures to meet. Earth has corrupted Eden, and now the animals and people and weird Boschian abominations all have things to say.

So now there's a whole new place to explore and all new kinds of interactions you can have with creatures, and if you were doing the text-message based scavenger hunt then maybe you got an item that some of the animals respond to or maybe you found a key that unlocks a chest filled with *treasures*...all kinds of stuff is going on. I can't describe it all. It was too much. Remember: 400 artists and volunteers were making this happen.

You're wandering around, exploring, collecting tokens, interacting with creatures, taking up challenges—whatever you want to do. There is a station where you can print the music tablature from the painting on your butt. There is 'The Spark of Life' exhibit where you can watch life created by Tesla coils and crawl out of the muck. Confession booths. Lots of berries. Giant bird nests. A university of bull-shit. A Rococo feast of bound diners with ball gags. It felt, to me, what I thought it would feel like to be in the Earth panel of the painting. But all good things must end, and suddenly the soundscape goes silent, and the lights go dark, and all the creatures start to go into hibernation, and a path is lit up into the darkness, and a celestial chorus begins singing as you are guided along the path. The Descent Into Madness, to the Hell section of the triptych.

And at that point...well...let's just summarize. There is lava. A lot of it. There's an orchestra. It's actually an Orcastrophy. A Fiascophonic Orcastrophy. And dancing demons. And **The Trickster** is back, and then behind him you see **The Docent** from the museum giving a tour to a whole new group of people (these are actors) who are looking at YOU from a stage, and you realize that you really are in the painting. Tourists wearing San Francisco sweatshirts like they sell on the Wharf are looking into the Hell panel of the triptych and the damned, which is now you. **The Docent** and **The Trickster** exchange hard words about the nature of Control and Chaos, and how without Control there would be anarchy but without Chaos there would be no fun. They argue, then cross swords. In shadowplay. The eternal battle for good and evil, which no one can win, ends this time with two bodies on the stage with swords stuck through them, and the orchestra and choir go nuts, and the whole crowd rocks out as **All** comes to an end, for now...

After the end of everything

When it's over, you walk back out through the painting, to find the whole gallery you walked in from has changed. All the paintings that you were looking at before are gone, replaced now with Lee van Laer's slideshow interpretation of *The Garden of*

Earthly Delights, all framed and lit with the little descriptions for you of all the things you just saw inside the painting. There is also a live, hosted slideshow happening if you want to see *all* the slides.

But right by the exit, there is something you weren't expecting to see...

A ticket booth.

There are actually three Fallen Cosmos shows, and the only way someone can go to the next one ...

...you guessed it...

...is to be given a ticket. And the only place the ticket is for sale, is right here, right now. So if you want to give this experience you've just had to someone else, you can do that. Right now. You can keep it going if you want to. You can give this experience to someone else.

All three shows were packed.

It. Was. Amazing.

Treasure, part III

The final night of the Fallen Cosmos, I simply didn't have $500 to put in the trunk. I was completely, utterly, absolutely wiped out. All capital resources depleted. To the point; I actually used the $63 in ones that was left in the trunk earlier that day to buy fuel for the generator.

This is a terrible ending to a story.

So I will leave you with the text and image from the last slide of Lee's interpretation:

> *"And here we reach the final scene of the entire masterpiece, in the upper right hand corner of the painting. The thin white figure of a human being, one tiny entity in a landscape of forces far beyond his control, confronts the acrobatic shape of a demon, sword in hand, poised for battle. The forces of good and evil are still locked in mortal combat for men's souls. The theme of the struggle of these dualities is still not laid to rest...*

> *...It is, after all, eternal."*

Template for unrestricted generosity

I'm telling you about the Fallen Cosmos in such detail because I want you to see how every decision we made we made organistically. We didn't let any Control energy in. We had a vision for what we wanted to do and we stuck with it. We had a constitution that we were very clear about and we built a temporary, sovereign zone out of magic with a 51-word charter on a crowdfunding site. We made an environment no self-respecting Djinn could ignore. It was 2½ hours of *duende*. We did it with an organization that has no 'real estate' and isn't on a path to get any. We were able to do it on the scale that we did because we live in a city of art and innovation filled with artists and innovators in a million micro-movements who all want to trade in units of interesting instead of money.

There was risk. Palpable risk. People could have not bought the tickets. The content could have not come together. It could have rained.

But in that risk is also the opportunity to plug in to the ineffable and connect with what is important above all: spending the moments of your life doing pointless and intentional things in collaboration with others of your ilk. Summoning fairies that create magic moments that last forever.

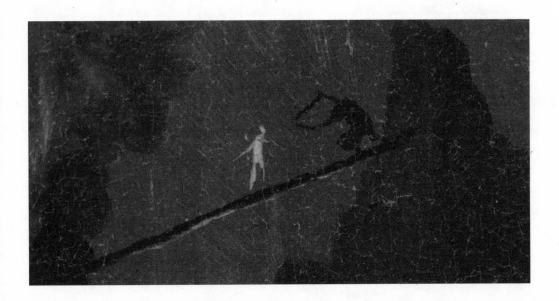

Citations

pg 3
Dali quote CHECK WEB CITATION FORMAT
'Salvador Dalí Quotes (Author of *The Secret Life of Salvador Dalí*).' Salvador Dalí Quotes
(Author of *The Secret Life of Salvador Dalí*). Goodreads, n.d. Web. 18 Aug. 2016.

pg 4
Kerouac quote
Kerouac, Jack. Lonesome Traveler. London: Penguin, 2000. Print.

pg 8
HARPERS INDEX
NPR rundown of some big world problems
Web. 19 Aug.2016.
http://www.npr.org/sections/goatsandsoda/2016/07/23/486924567/the-u-n-s-rundown-of-some-of-the-worlds-
biggest-problems

Number of people self employed in the US: 30% Three-in-Ten U.S. Jobs Are Held by the Self-Employed and the
Workers They Hire. Pew Research Centers Social
Demographic Trends Project RSS. N.p., 22 Oct. 2015. Web. 19 Aug. 2016.

Number of people self employed in the US 1948 & 1990
http://www.bls.gov/mlr/1996/01/art1full.pdf Web. PDF. 19 Aug.2016.

Oakland highest number of artists filing taxes: PDF web. 19 Aug. 2016.
Bureau of Labor Statistics Occupational Employment and Wages, May 2015

Number of women employed by non profits: 75%
Howard, Caroline. Why Female CEOs Thrive In Nonprofits. Forbes. Forbes Magazine, 24 Apr. 2015. Web. 19 Aug.
2016.

Amount that arts contributed to our economy: 704.2 billion
News. Arts and Cultural Production Contributed $704.2
Billion to the U.S. Economy in 2013. N.p., n.d. Web. 19 Aug. 2016.

Number of non profits in 1975: 247,086
https://www.irs.gov/pub/irs-soi/20yreo.pdf

Number of Non-profits in 2015: 1,500,000
How Many Nonprofit Organizations Are There in the U.S.? GrantSpace. N.p., n.d. Web. 19 Aug. 2016.

Number of pennies in a dollar the Black Rock Arts Foundation ended up going to art in 2009: 27
Berton, Justin. BURNING MAN TRIES TO COPE WITH CASH. SFGate. N.p., 19 Aug. 2007. Web. 19 Aug. 2016.

Average salary of a farmer in rural Europe in 1510: $15,000
Bregman, Rutger, and Elizabeth Manton. Utopia for Realists: The Case for a Universal Basic
Income, Open Borders, and a 15-hour Workweek. N.p.: Correspondent, 2016. Print.

Average salary of same farmer in 1840: $15,000
Bregman, Rutger, and Elizabeth Manton. Utopia for Realists: The Case for a Universal Basic
Income, Open Borders, and a 15-hour Workweek. N.p.: Correspondent, 2016. Print.

Average salary of same farmer today: $75,000
Bregman, Rutger, and Elizabeth Manton. Utopia for Realists: The Case for a Universal Basic
Income, Open Borders, and a 15-hour Workweek. N.p.: Correspondent, 2016. Print.

Number of people that have access to a working toilet: 64%
Wang, Yue. More People Have Cell Phones Than Toilets, U.N. Study Shows | TIME.com. NewsFeed More

Year that 6 of the 7 billion people on earth had a phone: 2013
Wang, Yue. More People Have Cell Phones Than Toilets, U.N. Study Shows | TIME.com. NewsFeed More

People Have Cell Phones Than Toilets UN Study Shows Comments.
Time, 25 Mar. 2013. Web. 19 Aug. 2016.

Number of calories in a Subway Italian Classic: 410
Nutrition Information. Sandwich Calories & Nutritional Information Menu. N.p., n.d. Web. 19 Aug. 2016.

Number of counts of child pornography Jared Fogle the Subway guy was charged with: 343
http://www.npr.org/sections/thetwo-way/2015/11/19/456622271/jared-fogle-to-learn-sentence-for-sex-with-minors-child-pornography

Current number of artists in the US: 2,438,948
http://www.bls.gov/oes/current/oes271013.htm Web. 19 Aug. 2016.

Number of people in the usa who work: 125,520,000
U.S. Full-time Employees: July 2016, Unadjusted | Statistic. Statista. N.p., n.d. Web. 19 Aug. 2016.

Predicted number of artists when the US has 50% unemployment: 50,982,287
Thompson, Derek. A World Without Work. The Atlantic. Atlantic
Media Company, July–Aug. 2015. Web. 19 Aug. 2016.

Number of people who currently own 50% of the worlds wealth: 82
Stern, Andy, and Lee Kravitz. Raising the Floor: How a Universal Basic Income Can Renew Our Economy and Rebuild the American Dream. United States: Public Affairs, 2016. Print.

Year that it is predicted that the US will have 50% unemployment: 2032
Srnicek, Nick, and Alex Williams. Inventing the Future: Postcapitalism and a World without Work. London: Verso, 2015. Print.

Number of bombers the USA manufactured for WWII from 1941 to 1947: 350,000
United States Aircraft Production during World War II. Wikipedia. Wikimedia Foundation, n.d. Web. 19 Aug. 2016.

Number of wind turbines needed to supply 100% of the worlds power needs: 7 million
Meyers, Andrew. Wind Could Meet Many times World's Total Power Demand by 2030, Stanford Researchers Say. Stanford University. N.p., 10 Sept. 2012. Web. 19 Aug. 2016.

Maker: In 2016 alone, 1.45M people will attend Maker Faires worldwide. So 2006-2016 total = 5M attendees worldwide
Interview with Sabrina Merlo, outreach director Maker Media 17 Aug. 2016.

Here is a Libertarian for UBI: Web 12. July. 2016. http://bleedingheartlibertarians.com/2016/07/the-ubi-in-non-ideal-theory-and-ideal-theory/'.

pg 16
Lorca, Federico García, Christopher Maurer, and Di Giovanni Norman Thomas. In Search of Duende. New York: New Directions, 2010. Print.

pg 17 CHECK WEB CITATION FORMAT
Windling, Terri. Chasing Inspiration. Myth & Moor, 15 Oct 2015. Web. 18 Aug. 2016.

Transcript of Your Elusive Creative Genius, Elizabeth Gilbert. Tedtalks, Feb. 2009. Web. 18 Aug. 2016.

pg 18
Lorca, Federico García, Christopher Maurer, and Di Giovanni Norman Thomas. In Search of Duende. New York: New Directions, 2010. Print.

pg 19
Hirsch, Edward. *The Demon and the Angel: Searching for the Source of Artistic Inspiration*. New York: Harcourt, 2002. Print.

pg 28
Lenny Kaye first person to coin the term 'punk rock' *Nuggets: Original Artyfacts from the First Psychedelic Era, 1965–1968*."Wikipedia. Wikimedia Foundation, n.d. Web. 18 Aug. 2016. <https://en.wikipedia.org/wiki/Nuggets:_Original_Artyfacts_from_the_First_Psychedelic_Era,_1965%E2%80%931968>.

pg 29 CHECK WEB CITATION FORMAT
Foundation Fact Sheet. Bill & Melinda Gates Foundation. N.p., n.d. Web. 18 Aug. 2016.

pg 31
Kim, Yoonj. Can Transformational Festivals Like Lightning In a Bottle Survive Their Own Popularity? Playboy. N.p., 3 June 2016. Web. 18 Aug. 2016.

pg 32
I and Thou, Buber, Martin 1923

In the bumper: Xygalatas, Dimitris Web. 19 Aug. 2016.
http://www.pewsocialtrends.org/files/2010/10/millennials-confident-connected-open-to-change.pdf

pg 33
Significant ways, Lewis, Saphir. "Festival Calendar." Festival Fire. http://festivalfire.com/festivals/, 2016. Web. 18 Aug. 2016.

pg 34
http://beachgothfest.com/ 'Beach Goth 2016.' Beach Goth 2016. N.p., n.d. Web. 19 Aug. 2016.

Vogueing
"Full Movie: *Paris Is Burning* (1990) for Free. | Ffilms.org." Ffilmsorg. N.p., 03 Sept. 2014. Web. 18 Aug. 2016. <http://ffilms.org/paris-is-burning-1990/>.

pg 36
Laurenson, Lydia. My Year in San Francisco's $2 Million Secret Society Startup. Motherboard. Vice, 7 Mar. 2016. Web. 19 Aug. 2016.

pg 50
Craislist: One in five households have internet: Internet Users. Number of (2016). Real Time Statistics Project, n.d. Web. 18 Aug. 2016.

pg 51
Fitch, Anna "director" on Vimeo: *Bugworld part I and II* Web. 19 Aug. 2016.
https://vimeo.com/channels/184430

Black Arts: The $800 Million Family Selling Art Degrees and False Hopes, Forbes Magazine, Web. 18 Aug. 2016
http://www.forbes.com/forbes/welcome/?toURL=http://www.forbes.com/sites/katiasavchuk/2015/08/19/black-arts-the-800-million-family-selling-art-degrees-and-false-hopes/

pg 64
Sortition (stocacracy)
Dowlen, Oliver. *The Political Potential of Sortition: A Study of the Random Selection of Citizens for Public Office*. Charlottesville, VA: Exeter, UK, 2008. Print.

pg 65, 70, 72
Tsai, Robert L. *America's Forgotten Constitutions: Defiant Visions of Power and Community*. N.p.: Harvard UP, 2014. Print.

pg 77
Wilson, Peter Lamborn. *Pirate Utopias: Moorish Corsairs & European Renegadoes*. Brooklyn, NY: Autonomedia, 2003. Print.

pg 81
Huizinga, Johan. *Homo Ludens: A Study of the Play-element in Culture*. London: Routledge, 1949. Print.

Jack Spade forced out of business by Chicken John, Fashionista. Wed Aug 19. 2016,
http://fashionista.com/2015/01/kate-spade-saturday-shuttering-stores

pg 87
Kleptocracy Web Aug 19. 2016.
http://www.governmentvs.com/en/kleptocracy-countries/model-64-4

pg 95
Quote. BrainyQuote. Xplore, n.d. Web. 18 Aug. 2016. <http://www.brainyquote.com/quotes/quotes/h/henry-ford136294.html>.

pg 109
van Laer, Lee, *Esoteric Analysis*, E-book Web Aug 19. 2016
http://www.esotericbosch.com/Garden.htm